S0-AAC-050
3 9896 01313 4073

Dodgeville Public Library
139 S. Iowa St.
Dodgeville, WI 53533

WITHDRAWN

THE STORYTELLERS

THE STORY TELLERS

Narratives in International Contemporary Art

Edited by Selene Wendt

SKIRA | TrAP | Office for Transnational Arts Production | STENERSEN museum

Eloísa Cartonera
for the cover

Design
Marcello Francone

Editorial Coordination
Emma Cavazzini

Editing
Doriana Comerlati

Layout
Sara Salvi

First published in Italy in 2012 by
Skira Editore S.p.A.
Palazzo Casati Stampa
via Torino 61
20123 Milano
Italy
www.skira.net

© 2012 Selene Wendt
© 2012 Skira editore
© Georges Adéagbo, Ulf Nilsen,
by SIAE 2012

All rights reserved under international
copyright conventions.
No part of this book may be reproduced or
utilized in any form or by any means,
electronic or mechanical, including
photocopying, recording, or any information
storage and retrieval system, without
permission in writing from the publisher.

Printed and bound in Italy. First edition

ISBN 978-88-572-1721-5 (Stenersen
Museum)
ISBN 978-88-572-1480-1 (Skira editore)

Distributed in USA, Canada, Central & South
America by Rizzoli International Publications,
Inc., 300 Park Avenue South, New York, NY
10010, USA.
Distributed elsewhere in the world by Thames
and Hudson Ltd., 181A High Holborn,
London WC1V 7QX, United Kingdom.

This book coincides with the exhibition

The Storytellers:
Narratives in International Contemporary Art

Curated by Selene Wendt
in collaboration with Gerardo Mosquera

Produced by Transnational Art Production

CONTENTS

THE ART
OF STORYTELLING

Selene Wendt

The story begins on the pages of the literary treasures that turn libraries into places of magic and wonder. Inspired by the powerful narratives that unfold in award-winning books, the artists featured in *The Storytellers* translate the stories of legendary authors into magnificent works of art. This exhibition was initially inspired by a personal interest in Latin American literature and its distinct tradition of storytelling. Authors such as Jorge Luis Borges, Pablo Neruda, Mario Vargas Llosa, Gabriel García Márquez, Octavio Paz and Reinaldo Arenas have all had a tremendous influence on the development of literature and poetry both in their home countries and internationally. Neruda's poems, Borges' labyrinths and Márquez's magical realism, is the stuff that bibliophile dreams are made of. Through the years, their stories and poems have provided a valuable source of inspiration not only for other authors, but also for artists. More than ever before, the impact of literature is also seen within the realm of international contemporary art. While the inspirational seed for this exhibition was planted in Latin America, it has grown and blossomed far beyond its roots, reaching across geographical, linguistic, and creative borders. The result is an exhibition that features contemporary artists from around the world whose work is also inspired by authors such as James Joyce, William Blake, Karl Marx, Virginia Woolf, Italo Calvino and Arthur Rimbaud. The exhibition title is directly inspired by Mario Vargas Llosa's book *The Storyteller*, a captivating story with an intricate narrative that juxtaposes the voice of the narrator with chapters relating to Peruvian Indian mythology. *The Storyteller* contains all the elements of a classic, award-winning novel: an underlying personal struggle and a search for meaning and truth found along the path of a life-changing journey of discovery. The

story hints at many of the underlying themes in this exhibition, and also captures the unique and powerful storytelling qualities of many of the artists featured. Just as Mario Vargas Llosa guides us into a mythic and magical world with his poetic tale of a storyteller, the artists included in this exhibition are visual storytellers who capture our imagination with their interpretations of some of the greatest stories ever written.

"The Storyteller" is also the title of a celebrated essay by Walter Benjamin, written specifically about the work of Nikolai Leskov. Benjamin's reflections on the qualities and power of true storytellers are highly relevant within the general context of literary theory, and also within the specific context of this exhibition. Although Benjamin feared the end of the art of traditional storytelling, his words are nonetheless insightful. He writes: "Counsel woven into the fabric of real life is wisdom. The art of storytelling is reaching its end because the epic side of truth, wisdom, is dying out."[1] Benjamin had a very valid point in terms of oral storytelling, but clearly the art of storytelling in the written form will never die out, and visual storytelling is blossoming like never before. Benjamin describes the inherent qualities of storytelling, placing emphasis on the roles of both the storyteller and the listener. Within the context of this exhibition, the parallel is easily extended to the roles of artist and viewer.

> Storytelling is always the art of repeating stories, and this art is lost when the stories are no longer retained. It is lost when there is no more weaving and spinning to go on while they are being listened to. The more self-forgetful the listener is, the more deeply is what he listens to impressed upon his memory. When the rhythm of work has seized him, he listens to the tales in such a way that the gift of

retelling them comes to him all by itself. This, then, is the nature of the web in which the gift of storytelling is cradled. This is how today it is becoming unravelled at all its ends after being woven thousands of years ago in the ambience of the oldest forms of craftsmanship.[2]

The installations, sculptures, photographs, films, paintings, and drawings featured in *The Storytellers* are not literal interpretations, nor are they illustrative, but they are all deeply inspired in some way by literature and/or poetry. As with any story, the narratives are intricate and intertwined, sometimes overlapping, move in and out of time and place, are rich with metaphor and symbolism, and are conveyed with unequivocal power and conviction. Some of the underlying narratives evolve from personal journeys, others are more analytical or theoretical in approach, but all the works tell stories that are as personal as they are universal. The golden thread that ties these works together is typically spun from pre-existing literary narratives, found in timeless, epic stories that are uniquely transformed into new stories in their own right. The cross between text and image, poetry and poetic subject matter brings all the work together into a large-scale exhibition that can be read and enjoyed on a variety of different levels. Reading between the lines of these works, we are invited to discover what shapes this exhibition into visual storytelling at its best.

These artists are storytellers in their own right, with a unique ability to convey narratives through visual art that is paradoxically as indebted to words, text and language as it is detached from the words, text and language that inspired them in the first place. While the play between text and image is certainly nothing new, these works reveal a very specific and unique link to literature. The essence of this exhibition lies in the refer-

ences to specific literary narratives as well as the individual narratives that are also inspired by literature and books. Real books, imaginary books, replicas of books, book collections, pages from books, passages from books, pictures of books, installations of books, and sculptures carved from books might all seem part of an imaginary Borgesian universe. As featured within *The Storytellers*, these books are visual translations that tell or re-tell captivating stories that ultimately trace a path from Jorge Luis Borges to James Joyce, from Brazil to Norway, from the nineteenth century to the twenty-first century and back again, expressed in art that speaks even louder than words.

The expression of pictorial narratives or storytelling without words began thousands of years ago with the first cave paintings, and has grown increasingly intricate and sophisticated throughout history. From the Palaeolithic cave paintings of Lascaux until today, images have been used in the place of words to convey easily understandable historical and religious narratives. The beliefs, ambitions and achievements of Egyptian pharaohs were beautifully expressed in the mural paintings of the pyramids and temples of Egypt, that when unveiled told the story of a long line of Egyptian kings and rulers. Similarly, the Medieval and Renaissance frescoes that decorate churches throughout Europe are classic examples of visual storytelling at its best, relaying stories from the Bible to all.

Within contemporary art, while personal narratives are interesting in their own right, it is particularly fascinating to see what happens when artists create work based on the already existing narratives of award-winning authors and poets. The stories that unfold range from short to long, and are quite possibly already familiar to the

viewer. This is precisely what links these particular artists together, as presented in works where the narratives are typically more important than actual words or texts. As seen in this exhibition, these artists tell a wide variety of stories through visual means that extend far beyond written language. Ultimately, their works transcend the borders of geography, language and discipline, and collectively convey universal stories of life.

Jacques Rancière speaks quite convincingly about the role of the artist as storyteller, describing an emancipated community as one made up of storytellers and translators.

> Artists, just as researchers, build the stage where the manifestation and the effect of their competences become dubious as they frame the story of a new adventure in a new idiom. The effect of the idiom cannot be anticipated. It calls for spectators who are active as interpreters, who try to invent their own translation in order to appropriate the story for themselves and make their own story out of it. An emancipated community is in fact a community of storytellers and translators. I am aware that all this may sound as: words, mere words. But I would not hear this as an insult.[3]

Each of the artists in *The Storytellers* builds a stage where they not only frame the story of a new adventure in a new idiom, they re-frame, re-stage, and re-create stories that have already been told. As viewers we take on the role of spectators, and are inspired to play an active role as interpreters. There is no escaping the immediacy of these works, and the more time we take to read between the lines, embracing our roles as interpreters, the richer the stories become. As we enter Alfredo Jaar's *Marx Lounge*, we are encouraged to take time to read the books that are laid out before us. Inside Ernesto Neto's *Circleprototemple*, we are intended to beat the drum. As we walk through Monika Bravo's *Landscape of Belief*, we are completely surrounded by and transported into a Calvino-inspired environment.

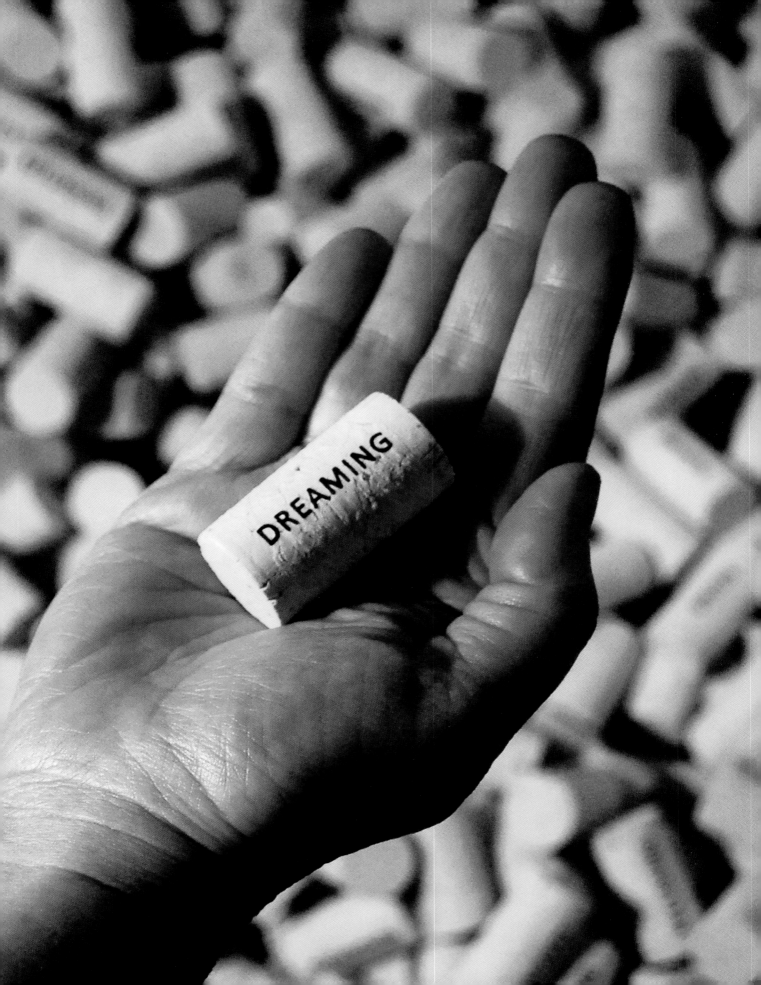

Chapter One
THE CIRCULAR RUINS

Ernesto Neto

To enter the world of Ernesto Neto is to take a personal journey of the imagination, and with *Circle-prototemple*, 2010, we are also introduced to the philosophical and metaphysical world of Jorge Luis Borges. Neto's installation makes specific reference to "The Circular Ruins," an intricate and complicated tale that involves the journey of a wizard who enters circular ruins where he has one goal, to create a son through his own dreams and imagination. After countless days of sleeping, he dreams of a beating heart that he believes to be the first successful step towards his goal. On the most basic level, the story relates to Borges' observation that "one's perception of reality could be an elaborate illusion." Throughout the story, there is a very fine line created between perception and reality, but in the end, the wizard comes to the realisation that the imagined son only exists in his dreams. Even worse, he also discovers that he too is just the figment of another person's imagination. The following passages from "The Circular Ruins" are the direct source of inspiration for Ernesto Neto's installation.

He dreamed that it was warm, secret, about the size of a clenched fist, and of a garnet colour within the penumbra of a human body as yet without face or sex; during fourteen lucid nights he dreamt of it with meticulous love. Every night he perceived it more clearly. He did not touch it; he only permitted himself to witness it, to observe it, and occasionally to rectify it with a glance. He perceived it and lived it from all angles and distances. On the fourteenth night he lightly touched the pulmonary artery with his index finger, then the whole heart, outside and inside.[4]

Ernesto Neto's red, heart-shaped structure is a fantastic metaphor for the beating heart described in Borges' story; the drum inside immediately brings to mind the intense sound of a heartbeat. Neto is internationally renowned for his experiential textile installations, which are so playful that they can bring out the inner child, even in the most serious adults. Once the initial wow factor has settled, the subtle underlying messages slowly become clear. This is the inherent paradox and brilliance of Ernesto Neto's work. Immediate associations to children's play environments give way to more existential ideas if one

approaches his artwork with Zen-like mindfulness. While people of all ages relish in the sheer pleasure of Neto's ambient installations, his works also capture something more diffuse and difficult to define, which is precisely what gives his artwork depth beyond the form.

Beneath the bright and colourful surfaces and sheer playfulness of Neto's sculptural environments lies respect for true craftsmanship and an interest in conveying more than what first meets the eye. Social interaction is always at the core of these works and the notion of individual journeys of discovery runs like a golden thread throughout the work. As active participants in these environments, we essentially enter into vessels that carry us on magical, experiential journeys where we are enveloped by colours, shapes, smells and sounds that speak powerfully of our relationship with the world around us and the universal balance between living things. With *Circleprotemple*, Ernesto Neto invites us not only on a journey, he brings us straight to the heart of Borges' story. In an interview for *Studio International*, on the occasion of his solo exhibition at the Hayward Gallery in London, Ernesto Neto described this aspect of his work quite beautifully: "My goal is to embrace people, take care of people, carry them as if I were carrying a baby. The space in which I work is pre-language space. It is an area for understanding the physical world, texture, weight, colour, temperature, joy, and sadness. It is the space of affective relationships with the world."[5] In fact, returning to Jacques Rancière's theory, we become active interpreters in the same moment that we actively engage in *Circleprototemple* and relate to it physically, emotionally and intellectually.

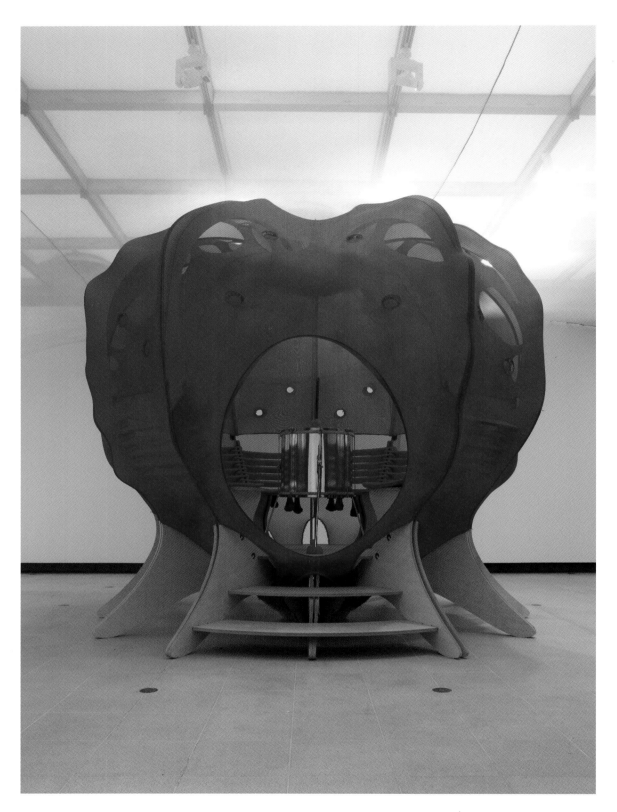

Ernesto Neto
Circleprototemple
2010
Courtesy of Galeria Fortes
Vilaça, São Paulo

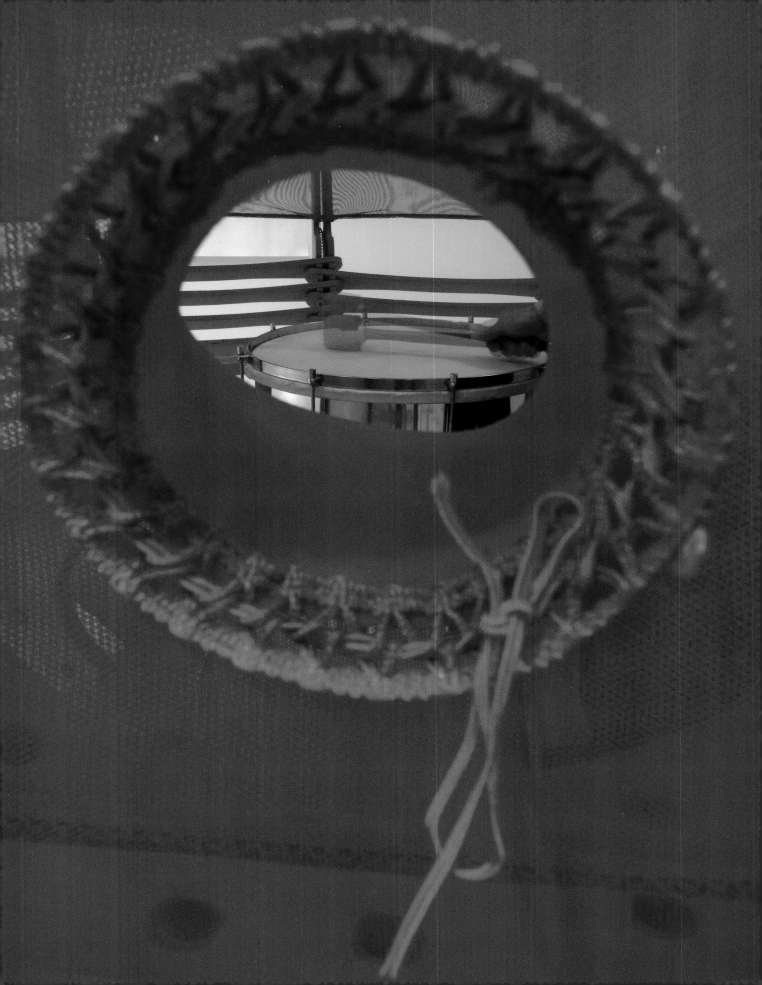

Chapter Two
THE BOOK OF SAND

Marilá Dardot

Marilá Dardot captures the complexity and mystery of Jorge Luis Borges' famous short story, *The Book of Sand*, in an exquisite work that she created in 1999. Her interpretation of this Borgesian tale is, in fact, a book of mirrors. From a bibliophile's perspective, the work resonates with the beauty of a rare and coveted book. The conceptual power lies in the link to the paradoxical book that is featured in Borges' short story, which is built around the idea of a book whose pages are infinite. As described in classic Borgesian prose, "neither sand nor this book has a beginning or an end." As is typical for Borges, the tale is spun from an intricate web of secrets, treasures, riddles, and dreams related in a surreal and unforgettable narrative. Marilá Dardot's artwork is also inspired by the famous passage from Heraclitus' *Fragments* where he argues that no man can step twice in the same river. The meaning of this is widely interpreted as relating to the notion of a continuum and the ever-changing nature of life. We are never what we once were, and can never again be what we are right now. The combination of these two sources of inspiration is quite fascinating. Rather than creating a straightforward interpretation of Borges' tale, Dardot references an ancient philosopher and writer whom Borges was greatly inspired by. This double reference brings to mind Virginia Woolf; the link between Borges and Heraclitus is truly a classic example of "books having a way of influencing each other."[6] Books also have a way of influencing art, which is of course what *The Storytellers* is all about. Dardot explains that the reader of this book, or any other book, in fact, will never find the same meaning in its pages, even if they remain the same. In the end, Dardot has not only created an artwork, she has created an actual book that functions within an endless continuum where art, literature, life, and philosophy are inextricably bound together as part of an eternal quest for meaning where new questions arise just as soon as answers to earlier questions are found.

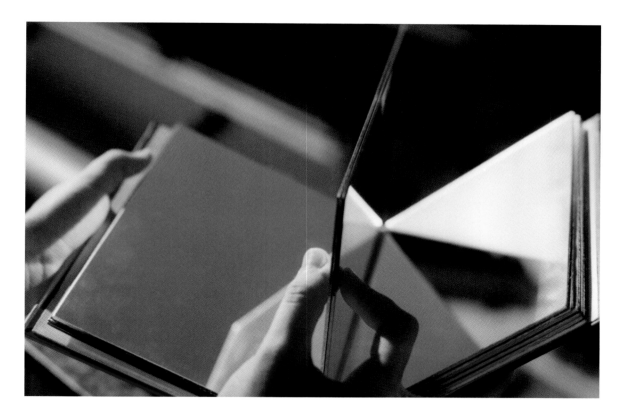

Marilá Dardot
The Book of Sand
1999
Book bound with pages
of mirrors
Courtesy of Galeria
Vermelho, São Paulo

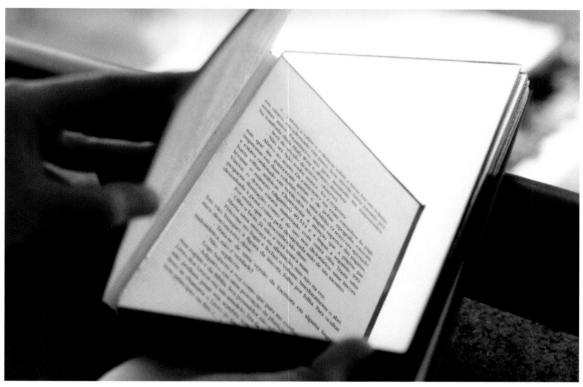

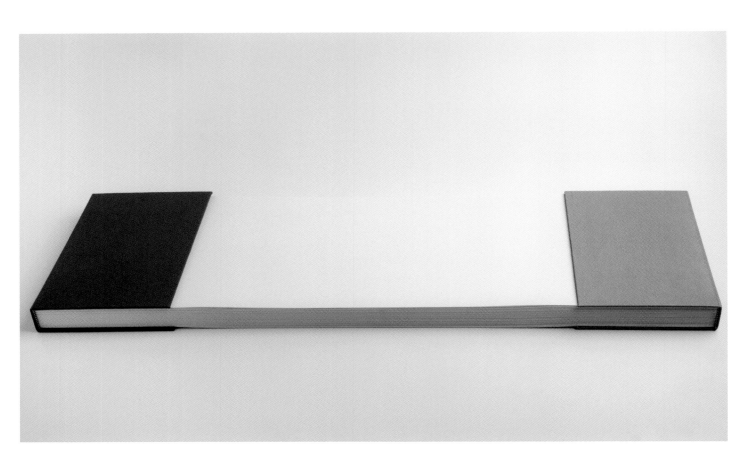

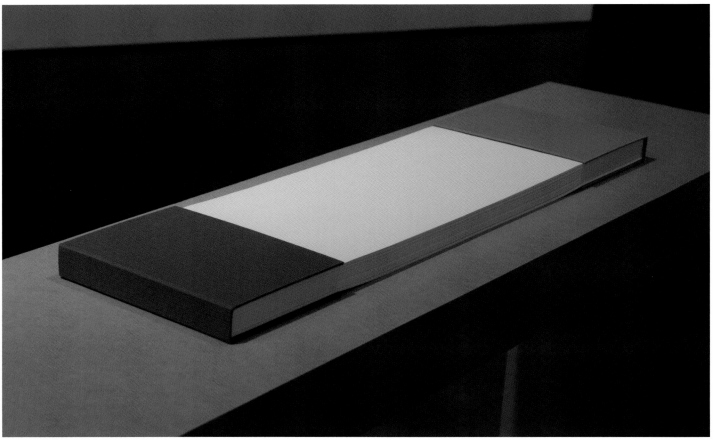

Marilá Dardot
Third Bank
2007
Book
Private collection,
São Paulo

Marilá Dardot
Ulysses
2008
Inkjet on cotton paper
mounted on acrylic
polyptych, 19 pieces
Private collection,
São Paulo

Chapter Three
THE HANDSOMEST DROWNED MAN IN THE WORLD

Tracey Snelling

In this classic work of magical realism, Gabriel García Márquez explores the blurring between myth and reality, as he often does. The moral of the story is the question of what happens when an imaginary, larger-than-life person enters the lives of villagers from a sleepy little seaside town. The encounter evolves into a life-changing experience for everyone, establishing the main character as a great individual with the power to significantly change people's lives, not only temporarily, but also permanently. Márquez's description of this man is as mythical as it is poetic: "Not only was he the tallest, strongest, most virile, and the best built man they had ever seen, but, even though they were looking at him, there was no room for him in their imagination."[7] And yet, this same man is so incredible that he slowly captures all their imaginations, to the extent that their lives change forever because of his presence.

Tracey Snelling's interpretation of *The Handsomest Drowned Man in the World* is a new work created specifically for *The Storytellers*. As such, it is a story yet to be told, but it is easy to imagine what is in store based on some of her earlier work. Tracey Snelling is known for her small multimedia installations. Typically, her works are conceived as small, almost dollhouse size, buildings with windows and doors filled with small LCD screens where various life stories unfold. Cinema is an important source of inspiration for Snelling, and cinematic influences are quite evident throughout her work. Less obvious perhaps, but equally important, is her interest in literature. She cites Albert Camus' *The Stranger* and John Steinbeck's *The Grapes of Wrath* as two of her favourite books.

For *The Storytellers*, Tracey Snelling created four additional works that are also directly inspired by Latin American literature and poetry. With the words from Reinaldo Arenas' beautiful poem in mind, I wonder if the walls will recede, if the roof will vanish, if I will float quite naturally, If I will be uprooted, dragged off, lifted high, transported and immortalised in my encounter with Snelling's interpretation of his touching parable of the creative experience of a great writer, *The Parade Ends*. Another work is inspired by Mario Vargas Llosa's critically acclaimed novel *The Bad Girl*, probably the most brilliant remaking and modernisation of Gustave Flaubert's *Madame Bovary* ever. Vargas Llosa's novel is essentially the tragic love story about a good boy who falls in love with a bad girl, and all the drama that happens along the way. No matter how often the bad girl betrays and hurts the good boy, he always welcomes her back, and so on and so forth until the tragic ending of the story. This is the drama that will inevitably play out in the tiny windows and doors of Snelling's work. Finally, in looking at her interpretation of Pablo Neruda's poem *The Night in Isla Negra* perhaps we will discover "the ancient night and the unruly salt beating at the walls," but only the viewer's active engagement in these works will reveal the stories that must be discovered individually and not revealed beforehand.

Tracey Snelling
Bad Girl (based on *The Bad Girl*
by Vargas Llosa)
2012
Wood, paint, lights, electroluminescent
wire, lcd screen, media player,
speaker and transformer
Courtesy of the artist and Rena Bransten
Gallery, San Francisco

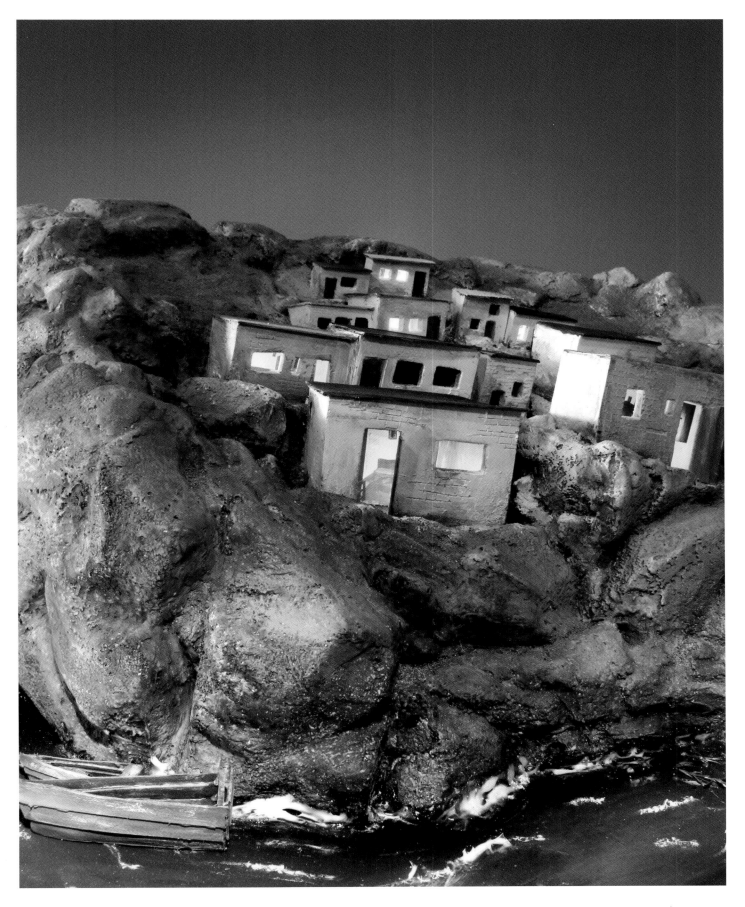

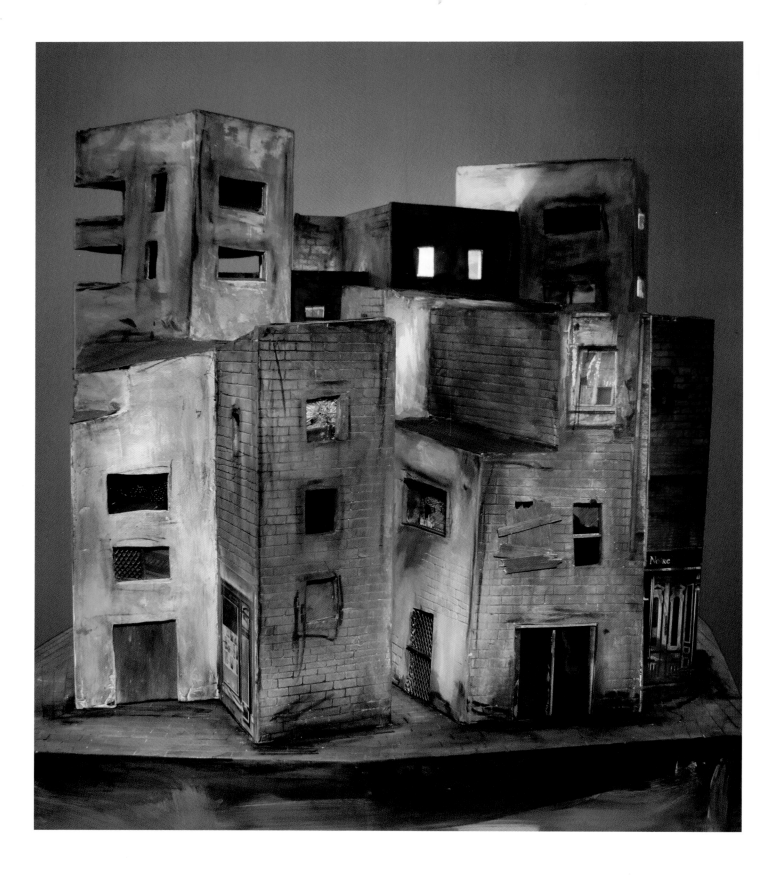

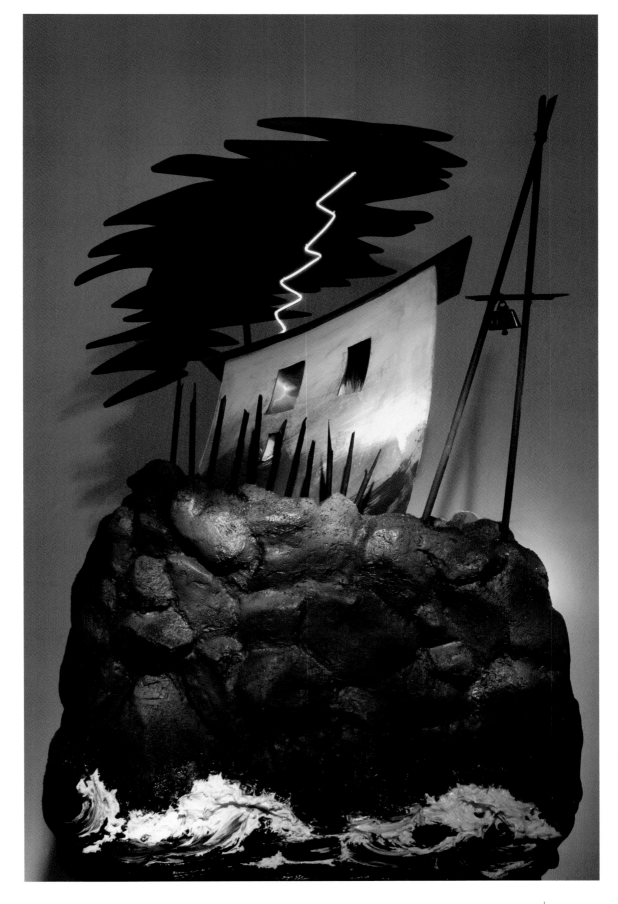

Tracey Snelling
The Parade Ends
(based on
The Parade Ends
by Reinaldo Arenas)
2012
Wood, paint, charcoal,
lights, lcd screen, media
player, speaker and
transformer
Courtesy of the artist
and Rena Bransten
Gallery, San Francisco

Tracey Snelling
Isla Negra
(based on *The Night
in Isla Negra*
by Pablo Neruda)
2012
Wood, landscaping, foam,
faux water, paint, lights,
electroluminescent wire,
lcd screen, media player,
speaker and transformer
Courtesy of the artist
and Rena Bransten
Gallery, San Francisco

Chapter Four
THE LABYRINTH OF SOLITUDE

William Cordova

William Cordova's installation *Laberintos (after Octavio Paz)*, 2008, was first shown in the 2008 *Greater New York* exhibition at PS1. To create the work, Cordova appropriated vinyl records from an Ivy League school in response to that institution's refusal to return two hundred Inca artifacts back to Peru after it originally borrowed them in 1914. The records are installed in a manner that results in an eye-catching labyrinth. Without knowing the history behind the artwork, one might interpret it as a witty homage to some of the legends of popular music. Of course, we all know not to judge a book (or a record) by its cover, so it should come as no surprise that there is a lot more at play here than music.

As indicated in the title, reference is made to Octavio Paz's book *The Labyrinth of Solitude*. The essays in this seminal book are predominantly concerned with the theme of Mexican identity, while also expressing the universal and profound feeling of solitude that arises at the end of the existential labyrinth. Octavio Paz makes a detailed analysis of Mexican history beginning with a look at Mexico's pre-Columbian culture, with particular emphasis on the 1910 Revolution. Beyond what there is to learn about Mexican history in this captivating book, it reads as a highly poetic description of solitude. To read what Paz has written in "The Dialectic of Solitude," perhaps the most riveting chapter in the book, is to read about the struggles of humanity, written from a highly philosophical yet equally poetic perspective:

> Solitude—the feeling and knowledge that one is alone, alienated from the world and oneself—is not an exclusively Mexican characteristic. All men, at some moment in their lives, feel themselves to be alone. And they are. To live is to be separated from what we were in order to approach what we are going to be in the mysterious future. Solitude is the profoundest fact of the human condition. Man is the only being who knows he is alone, and the only one who seeks out another. Man is nostalgia and a search for communion. Therefore, when he is aware of himself he is aware of his lack of another, that is of his solitude.[8]

Each sentence of Octavio Paz's writing is carefully built on equal parts poetic prose and insight. The complexity and magic of Octavio Paz's unique style of political and philosophical reflection is cleverly interpreted in William Cordova's labyrinth of records. As viewers, each of us will find our own visual path through the labyrinth, an apt metaphor relating to the existential labyrinth of life. With the words of Octavio Paz in mind, we are guided to discover the underlying messages of Cordova's installation. In fact, these messages are perfectly summed up in the final paragraph of "The Dialectic of Solitude," providing an ideal introduction to *Laberintos (After Octavio Paz)*, 2008:

> Modern man likes to pretend that his thinking is wide-awake. But this wide-awake thinking has led us into the mazes of a nightmare in which the torture chambers are endlessly repeated in the mirrors of reason. When we emerge, perhaps we will realise that we have been dreaming with our eyes open, and that the dreams of reason are intolerable. And then, perhaps we will begin to dream once more with our eyes closed.[9]

William Cordova
Laberintos (after Octavio Paz)
2008
Courtesy of Arndt Contemporary Art,
Berlin

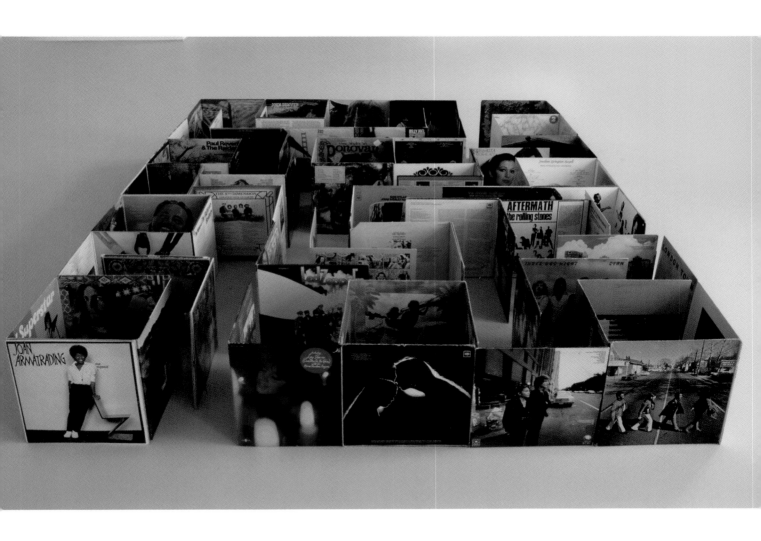

Chapter Five
INVISIBLE CITIES

Ulf Nilsen
Monika Bravo
Rosana Ricalde

Italo Calvino's *Invisible Cities* has long been a source of inspiration for Ulf Nilsen, and provides valuable insight into Nilsen's particular form of expression. When we consider many of the parallels with Calvino's work, the multiple meanings of various symbols emerge even more clearly. *Invisible Cities* is the story of Marco Polo who recounts to Kublai Khan about the many cities he has travelled during his voyages, cities that don't actually exist in reality—only in the narrator's imagination. All the descriptions are of Venice, depicted in infinite different ways.

Italo Calvino's strong use of symbolism is also reflected in Nilsen's paintings. It is interesting to read what Calvino writes about the power of symbols one cannot forget or make mistake of once they have been seen, as with the symbols that characterise Nilsen's work year after year. It bears relevance when Calvino writes: "The day I understand all symbols, will I finally succeed in being master of my domain?" For Nilsen, the symbols in his work are indicative of the questions that follow him through life, which therefore recur as an integral part of his work. The work reflects a search for identity through the visualisation of an inner struggle. As long as there are unanswered questions the symbols will remain elusive. At one point in the story Kublai Khan asks: "Is what you see always behind you?" Here Calvino points out that people have a tendency to seek out the past—the past that has evolved to dream, or parts of an earlier dream. The boundaries between dream and reality are wiped out completely as dreams are influenced by reality and reality is influenced by dreams.

For *The Storytellers*, Ulf Nilsen chose to create the site-specific mixed-media installation *Conceptions*, 2012, picking up the golden thread of Calvino's story and weaving it into a visual narrative that is paradoxically as subtle as it is powerful. While the visual play between text and image has dominated much of Ulf Nilsen's earlier work, this new work is a story without words. After years of being inspired by Italo Calvino, as expressed in richly symbolic paintings with direct references to the actual text, Nilsen has arrived at a place that is as strangely familiar as it is foreign. Questions that have interested Nilsen along the way still float in the air with the insistence of something that is immediately recognisable yet somehow impossible to grasp for more than a fleeting moment. (Having followed Ulf Nilsen's career over many years, I know this place intimately, this is the world of Italo Calvino as interpreted by Nilsen, and yet this is a new place even for me.)

Words have all but disappeared into the inner recesses of my mind, giving way to an even more complex and surreal interpretation of Italo Calvino, one that really embodies the true essence of Calvino on every level. The familiar components of Nilsen's work are all still there: the dichotomy between opposing worlds; a sense of travelling in circles in a quest for meaning; fragments of time—past, present and future all mingled into one; memories of tomorrow; silence so loud it could wake you from your dreams; a feeling of vulnerability; a sense of an eternal push and pull; dreamlike cityscapes that defy the imagination yet are also convincingly real, that is, until the moment when the reality disappears right before our eyes. As with each new reading of Italo Calvino's *Invisible Cities*, in looking at Ulf Nilsen's work for *The Storytellers*, we find ourselves surrounded by poetic invisibility. This is not something we can necessarily understand; we are intended to feel, experience and sense. This place is as linked to Nilsen's imagination as it is to Calvino's imagination; it is a magical place that emphasizes that reality is created in our own minds, as affected by time, memory, experience, and a search for existential meaning. Monika Bravo is another artist who is directly inspired by Italo Calvino. Bravo's *Landscape of Belief*, 2012,

is an interactive installation that ultimately questions how we construct our lives according to our belief systems. This work includes literary texts that float transparently in the space, where we become active participants and interpreters of the work. The texts are re-written not to create stories but skylines that are inspired by the surreal, imaginary cities described by Marco Polo in Calvino's *Invisible Cities*. By carefully overlapping clear, glass projection-surfaces, a sense of nothingness, or invisibility, is paradoxically conveyed as an object, in an interactive gallery space where the viewer is completely enveloped by the notion of metaphysical space.

Bravo first came up with the idea for *Landscape of Belief* after she came across the title of the exhibition *Textural Landscapes.* She envisioned a space covered with multiple landscapes, where a dynamic play between light, text, image and motion would create a powerful experience for the viewer. Monika Bravo refers to text as the potentiality of form, as the space in between, the vehicle of infinite probabilities. Monika Bravo's abstract visualisation of Calvino's *Invisible Cities* captures the ever-changing possibilities of the imagination and the mind, echoing the essence of Calvino's thoughts. Bravo's particular approach is as indebted to architecture as it is rooted in literature. Particularly relevant here is the significance of architecture on an ideological and utopian level. Monika Bravo creates a unique parallel between literature and architecture, bringing them together into a highly experiential space that defines, translates and shapes our understanding of both. As viewers we are invited not only to look at distant projections, we are literally immersed in these projected landscapes, given the opportunity to become aware of what Bravo refers to as the belief systems of these landscapes. These projections are not only references to Calvino's *Invisible Cities*, they are references to the ability of the imagination to create reality through belief.

If there were maps of Italo Calvino's *Invisible Cities*, they would probably resemble Rosana Ricalde's works on paper. She first began integrating maps into her visual language around 2006, and has created numerous works based on maps of cities, from Rio to Paris, as well as world maps. The streets in these maps are made of words extracted from various texts, ranging from Foucault to Calvino. From a distance the words are almost invisible, and even up close the words are mere fragments of text, extracted from a logical context. As such, these works map out a deconstruction of Calvino's *Invisible Cities*, challenging our understanding of visible reality, while literally forcing us to question what we think we see. The underlying meanings, and the direct link to Calvino in particular, is barely discernable from a distance. Beyond the understated beauty and obvious symbolism, there is a strong existential undercurrent that

transforms these works into something far more poetic than an actual map. The inherent opposition between the intangible, imaginary world of Calvino and the straightforward factual nature of a map creates a fascinating play of opposites that says as much about the nature of the original text as it does about Rosana Ricalde's ongoing fascination with books, language, text and words.

In the transition from language to visual form, Ricalde essentially deconstructs the original text, removing the grammatical logic of the words to create a story that is clearly more visual than linguistic. Extracted from the original context, the words are stripped of meaning, and no longer serve a narrative function. And yet there is a story being told in these works, even if it is not overtly narrative. This immediately brings to mind what Gerardo Mosquera has defined as denarration. This is the beauty of Ricalde's maps; while they echo the words of Calvino, more importantly they capture the essence of his work while simultaneously unravelling and deconstructing the original narrative. The logical sequence of words as they appear in Calvino's narrative is destroyed completely in favour of visual logic that, similar to Ulf Nilsen and Monika Bravo, speaks more about the underlying existential and philosophical messages of the book rather than a documentation of the actual cities described by Marco Polo or the events that take place.

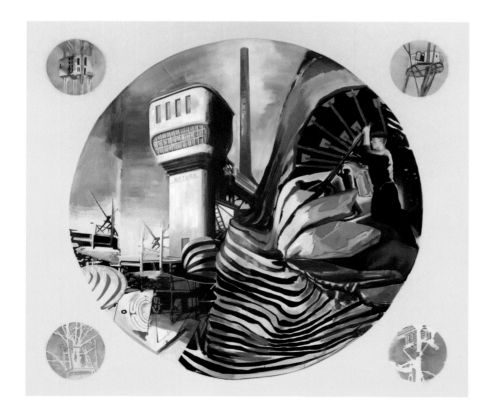

Ulf Nilsen
Conceptions
2012
Installation view
Photo Thomas Widerberg

Ulf Nilsen
Conception I
2012
Oil on canvas
Photo Thomas Widerberg

Ulf Nilsen
Study for Conceptions
2012
Charcoal on paper
Photo Richard Jeffries

Ulf Nilsen
Study for Conceptions
2012
Charcoal on paper
Photo Richard Jeffries

Ulf Nilsen
Conception III
2012
Installation
Photo Thomas Widerberg

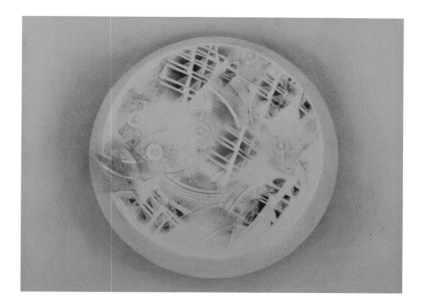

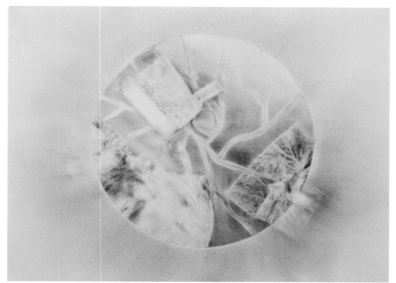

Here and opposite
Monika Bravo
Landscape of Belief
2012
Interactive time-based installation

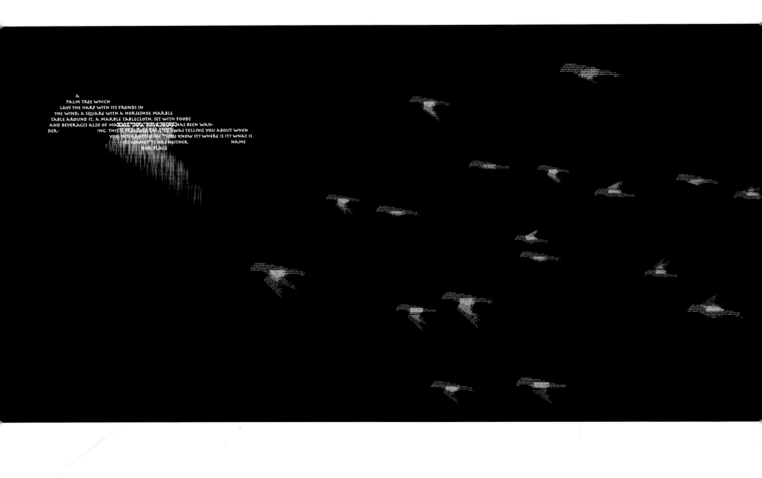

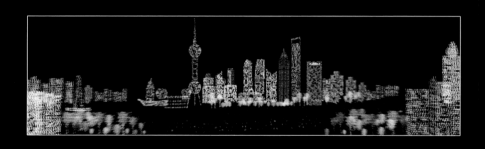

Rosana Ricalde
Mapa Mundi
2011
Work on paper
Courtesy Baró Galeria, São Paulo

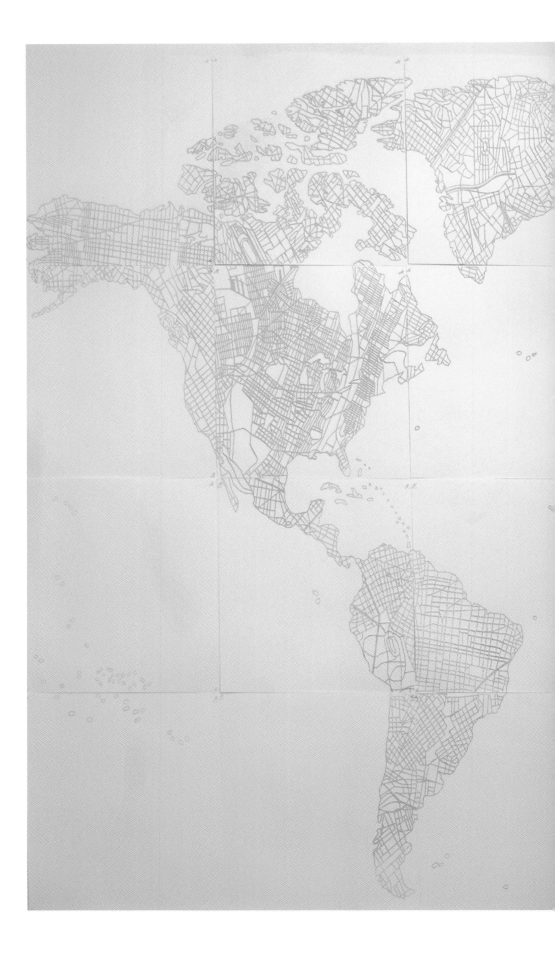

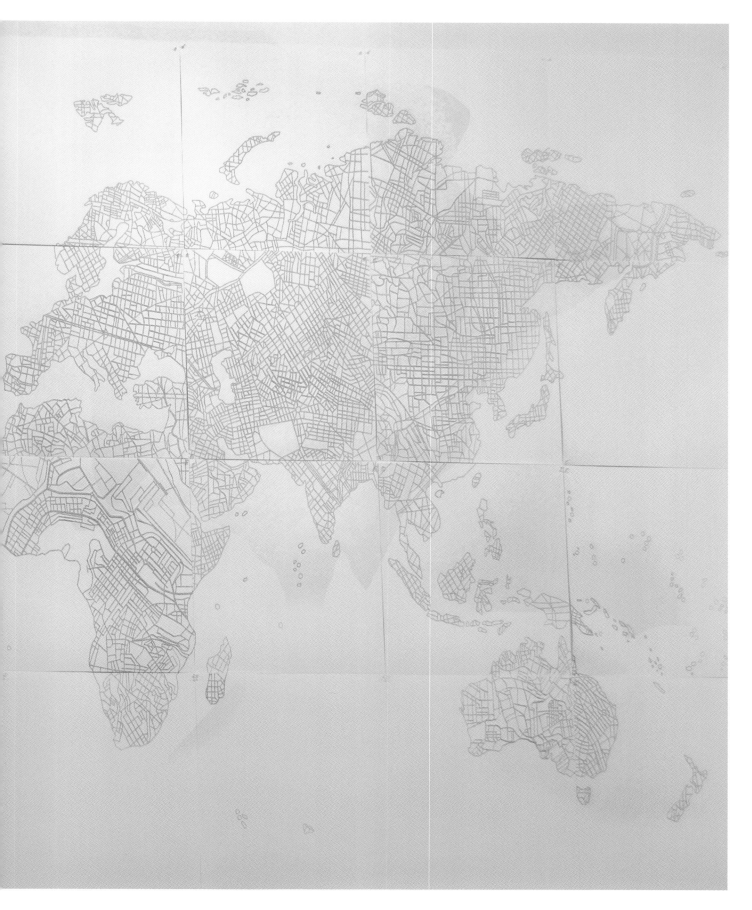

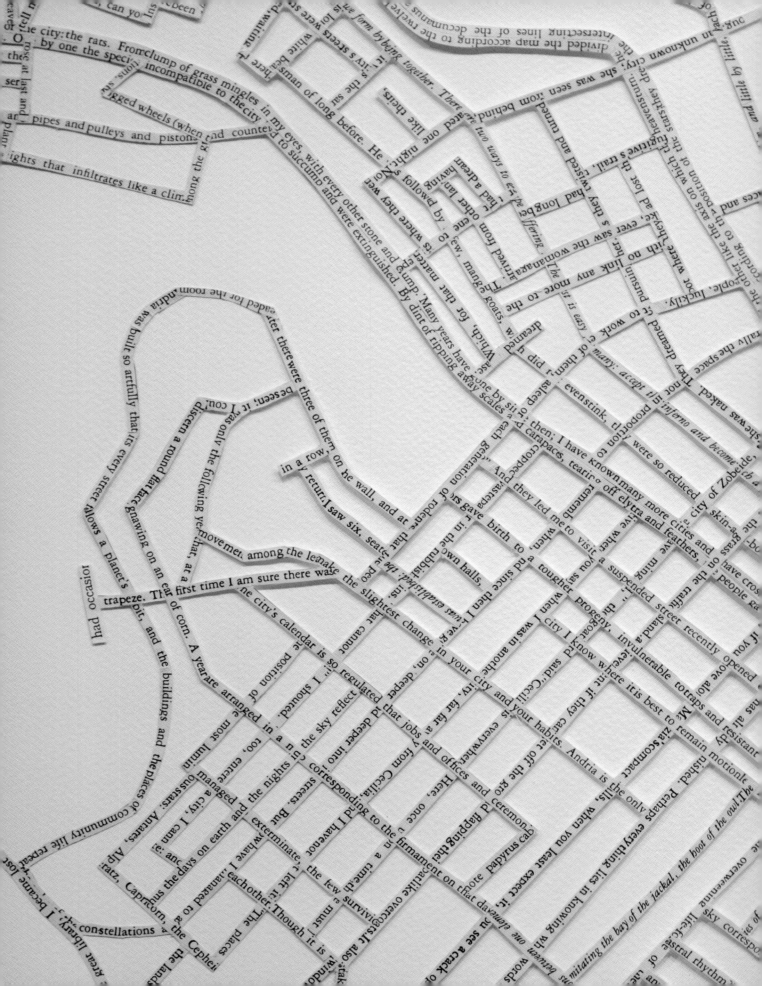

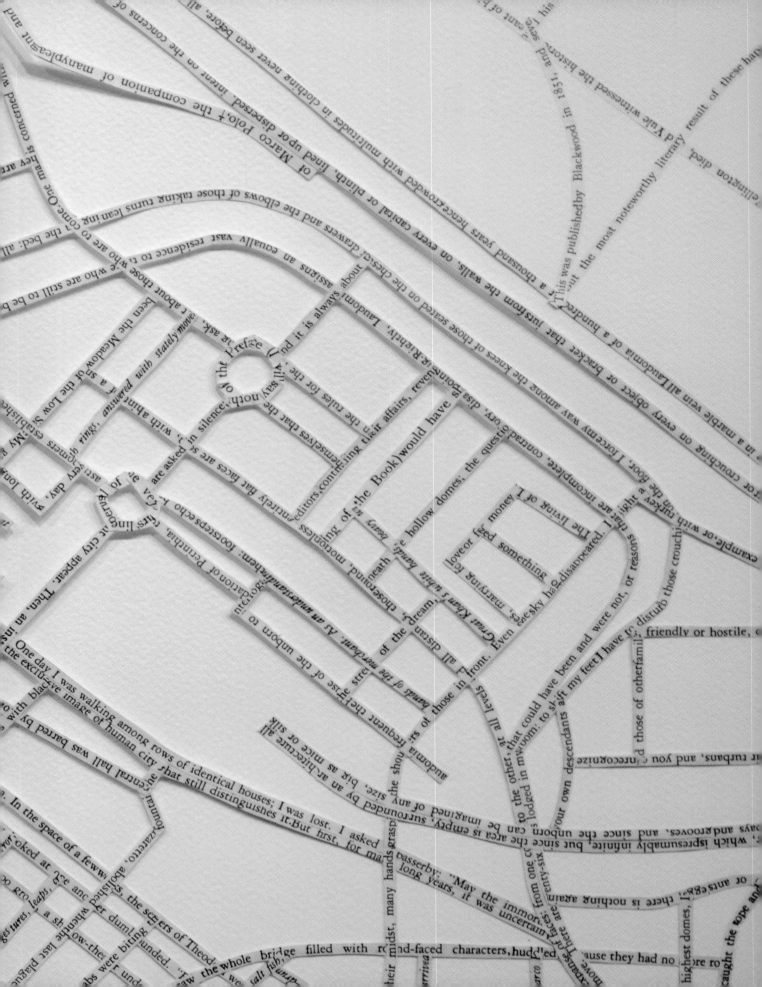

Chapter Six
THE COMMUNIST MANIFESTO

Alfredo Jaar
Milena Bonilla

Imagine walking into a spacious, beautifully designed, black and red room where there are hundreds of books to read and enjoy. This is not a library or a bookstore, and we are invited to stay as long as we like. Alfredo Jaar's *Marx Lounge* is more than an installation, it is a physical and theoretical intervention that requires the active participation of the viewer to be fully appreciated. Jaar describes it as a work-in-progress, one that changes slightly to adapt to each new exhibition location. As per his exact specifications, the walls are painted a warm shade of red, the lighting is perfect for reading, and there are plenty of comfortable sofas to sit in. There are approximately 1,500 paperbacks neatly stacked on a central table. The topics covered in the selection of books, all broadly related to Marxist thought, include economics, philosophy, history, psychoanalysis and, above all, politics.

The fact that it would take years to read all the books on display is an important aspect of the work. *The Marx Lounge* stands as a powerful counterpoint to the fast-paced society we live in, where, for many, there is little time to fully enjoy the pleasure of reading a book. Alfredo Jaar has a gift for conveying highly political messages in works that are as visually captivating as they are conceptually meaningful, and this work is no exception. The oversized table covered with a sea of books in different shapes, sizes and colours is an installation in its own right, while the deep red walls and potted plants contribute to cre-

ating a perfect environment for intellectual thought. Naturally, each person will be drawn to different books based on their own particular interests and perspectives. There are literally hundreds of ways to read the work, but no matter how or what we read in the work, every word on the pages of these books reminds us about the importance of knowledge and intellectual thought.

Alfredo Jaar speaks eloquently about the political ideals and intellectual thought that inspired the work, describing what artists do as an attempt to create new realities, and emphasizing the power of art to create them.[10] His fascination with conveying models of thinking about the world is certainly seen throughout his work, with each new project that he creates. Jaar's interest in politics and intellectual thought began many years ago, during the resistance to the military dictatorship in Chile. He was first introduced to Gramsci, then to Marx and the other thinkers whose books are featured in *The Marx Lounge*. Each one of these books contains a model of the world that suggests ways of changing it for the better. As such, *The Marx Lounge* not only conveys ideas related to political idealism, it suggests that there is a real need for a widespread intellectual revolution in our society.

Milena Bonilla's work *El Capital / Manuscrito Siniestro*, 2008, is based on one of the books in Jaar's *Marx Lounge*, Karl Marx' *Capital: Critique of Political Econ-*

omy—yet Bonilla's book is quite different from any of the books included in Jaar's installation. To make this highly conceptual, process-oriented work, Bonilla took on the task of rewriting the book word-for-word, chapter-by-chapter, with her left hand. As such, she transformed the book to a *manuscrito siniestro*. In Spanish, this has an important double meaning that refers both to the fact that it is written with her left hand, and also implies that it has a sinister meaning. Bonilla immersed herself completely in Marxist thought while creating this project, and even taught Marxist theory to art students at two universities during the process. She created two versions of the book, an exclusive version and a "pirate" version. Each edition is interesting in its own right, the exclusive version of particular interest because of the absurdity of creating an exquisite one-of-a kind, leather-bound collectors' edition of a book that is an outright critique of capitalism. The "pirate" version, on the other hand, is mass-produced in cheap paperback (with no regard for original copyright). This version is available to everyone, but the irony is that nobody can understand or interpret Bonilla's text because it is completely illegible. Interestingly, the work does not pay homage to Marx as one might think; rather, it is a critique of the left and what she perceives as its contradictions. It might seem at odds with the theme of *The Storytellers* to include a work that critiques the book that it was inspired by, but this is precisely what gives the work depth. As such, Milena Bonilla not only rewrites what has been written, she completely deconstructs it by making it illegible. Working with a book that almost everyone knows something about, gave her the absolute freedom to translate the original words into meaningless jibber. The original source is still immediately recognisable, and the title and cover itself establish the original source of literary inspiration, while Bonilla's approach functions as an artistic intervention more than a straight interpretation of the original book. In the end, her work is more than a critical interpretation of Marxism; it is also a deconstruction of some of the myths surrounding Marxist thought. Symbolically, she has singlehandedly re-written Marx, and what better way to rewrite the story than to do so in an unexpected, irreverent and provocative manner that might inspire new discussions surrounding the pros and cons of Marxist theory?

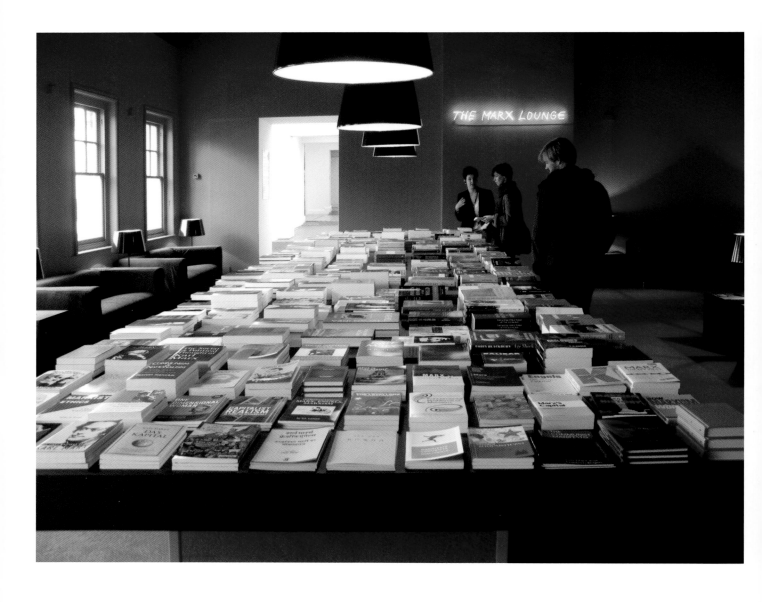

The Absolute Bourgeois

WALTER BENJAMIN'S ARCHIVE

THE ECONOMICS OF GLO...

Antonio Gramsci: Selections from the Prison Notebooks

...osa Luxemburg — The Accumulation of Capital

...osa Luxemburg — The Accumulation of Capital

Torrance

KARL MARX'S THEORY OF IDEAS

CAMBRIDGE

MARX — Grundrisse

PENGUIN CLASSICS

SASSEN — CITIES IN A WORLD ECONO...

ROBERT FISK

Beyond Chutzpah: On the Misuse of Anti-Semitism

Louis Althusser & Étienne Balibar — Reading Capital

GREEN GONE WRONG — HEATHER ROGERS

GREEN GONE WRONG — HEATHER ROGERS

An Orchestra Beyond Borders — ELENA CHEA...

THE EMANCIPATED SPECTATOR — JACQUES RANCIÈRE

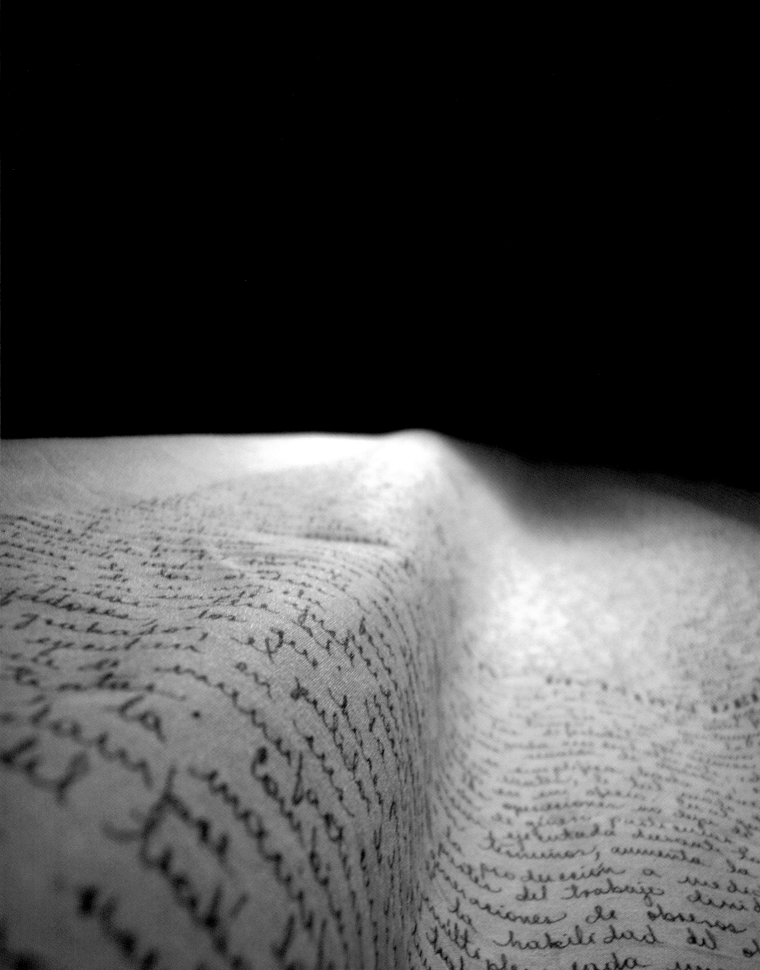

Chapter Seven
NOTEBOOK OF A RETURN TO THE NATIVE LAND

Liliana Angulo

Liliana Angulo's video installation *Négritude*, 2007–09, includes large mirrors etched with images from William Blake's book *The History of Slavery* along with images of Toussant L'Ouverture, and posters with the words *trabaje como un negro*, accompanied by a sound component with lyrics from salsa music. Angulo explains that some of the songs contain a strong legacy of colonial thinking and others address resistance to black male stereotypes. The message is loud and clear, there is absolutely no reason to dance to the rhythm of these songs. Liliana Angulo cleverly combines references to the colonial past with scenes of an Afro-Colombian man with a huge "Afro" hairstyle who dances salsa through the streets of Bogota, an approach that tells as much about the past as it does about the various kinds of oppression that continue to exist today.

The importance of the Martinican poet, playwright and politician Aimé Césaire in relation to this work cannot go unnoticed. Césaire's thoughts about African and Caribbean cultural identity and black empowerment in particular were compellingly expressed in *Cahier d'un retour au pays natal* (*Notebook of a Return to the Native Land*), a mixture of poetry and poetic prose. Among the most influential Caribbean writers of all time, Césaire spoke convincingly against French colonial racism, and was part of the group of intellectuals who coined the term *négritude.* A short excerpt from Césaire's *Notebook of a Return to the Native Land* reads as a perfect introduction to Liliana Angulo's spectacular multimedia installation. As the racist lyrics of the salsa songs pound inside your head, as you look at the reflections of backward colonial thinking, as you look at your own reflection, as you wonder if there is any irony or humour in the flashy Afro-Colombian man who dances around the streets of Bogota, let these words flow through your mind:

My negritude is not a stone
nor a deafness flung against the clamour of the day
my negritude is not a white speck of dead water
on the dead eye of the earth
my negritude is neither tower nor cathedral

it plunges into the red flesh of the soil
it plunges into the ardent flesh of the sky
my negritude riddles with holes
the dense affliction of its worthy patience

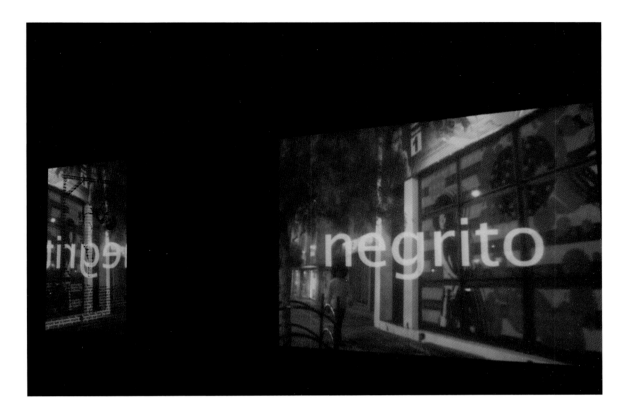

Liliana Angulo
Négritude
2007–09
Mixed-media video
installation with etched
mirrors with text and
images

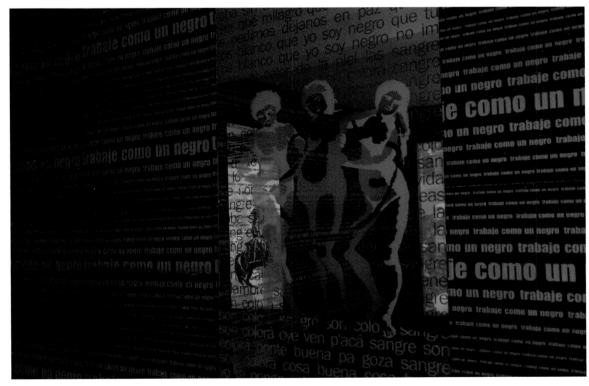

Chapter Eight
PARADISE IN THE NEW WORLD

Sergio Vega

Sergio Vega's *Paradise on Fire*, 2007 is inspired by the seventeenth-century book written by the Spanish historian Antonio de Leon de Pinelo, *El Paraíso en el Nuevo Mundo*. The photographs convey a personal journey that is best described in narrative form by Sergio Vega:

> Once I found a mouldy old book abandoned in the lower shelves of a political science library. It was an edition printed in the 1940s of a manuscript from 1650 published by the Peruvian government in celebration of the four hundredth anniversary of the discovery of the Amazon River. The book was last checked out in the 1970s but no one had read it even before that date since most pages remained uncut. The title was: *Paradise in the New World, Apologetic Commentary, Natural and Peregrine History of the Western Indies, Islands of Firm Ground of the Oceanic Sea by the Licentiate Don Antonio de Leon Pinelo from the Council of His Majesty and the Contracting House of Indies who resides in the city of Seville*. I remember the anxiety I felt as I carried the two heavy volumes into my studio. I would have never guessed that a chance encounter of this nature was going to determine the course of my life and work for years to come.
> The myth of South America as "paradise found" started with Columbus when he asserted in a letter to the Queen of Castilla that the entrance to terrestrial paradise was at the mouth of the Orinoco River. Columbus travelled with a copy of *The Travels of Marco Polo*. The Gulf of Paria resembled the description of a place in Asia the Venetian had taken for the Garden of Eden. The confirmation of a previous text is a substantial part of discovering, which makes the newly discovered thing not exactly new.
> Pinelo's thesis was based on the re-articulation of several previous theories about the location of Eden. In 1629 Jacques de Auzoles' treatise *Saincte Geographie* located Eden at the centre of South America. In Pinelo's version, Eden was not a rectangular garden, but a circular territory of 160 leagues (510 miles) in diameter, and the Paraná, the Amazonas, the Orinoco and the Magdalena where the four rivers of paradise. Pinelo's text reflected the intellectual transitions of the seventeenth century: it attempted to reconcile a theological account of creation with a scientific view of nature derived from the newly developing discipline of Natural History.
> When I decided to embark in the search of Pinelo's paradise I only had a copy of his book, a map of Eden drawn by Pedro Quiroz in 1617, and an airplane ticket. I was destined to reach into the very heart of South America and live to tell what I saw. Thus, my journey of discovery was bound to become the confirmation of a previous text, which was in itself the revision of a preceding one, and so on and so forth in a vast, never ending cacophony of echoes that went through Dante and Marco Polo all the way back to the Bereishit, the first book of the Torah.[11]

Vega's search for a mythical paradise brought him to Brazil. Deep within the lush, fertile Brazilian rain forest he found Mato Grosso, a place of idyllic beauty. He discovered rivers, swamps, mountains, archaeological sites, indigenous reservations, rural towns, shanty towns and even cities, with histories, tales, and legends all their own. As presented in the photographs, video and wall texts featured in *The Storytellers*, Vega's depiction of paradise also translates as a classic tale of personal discovery.

Here and following pages
Sergio Vega
Paradise on Fire
2007
Archival inkjet prints
Courtesy Galerie Karsten Greve,
St. Moritz

Chapter Nine
ULYSSES

Elida Tessler

Elida Tessler's work *Dubling*, 2010, is a true bibliophile's homage to James Joyce's literary masterpiece. The story that eventually led to the creation of Tessler's installation is a short story of its own. On a trip to Dublin for an academic conference, Tessler visited the settings that appear in James Joyce's *Ulysses*. At a café in France on another trip, she ordered an ordinary bottle of wine, and the cork had the word *espérance* (hope) stamped on it. As the waiter opened the bottle, he shrugged and philosophised about romance, citing James Joyce: "Man and woman, love, what is it? A cork and a bottle." Tessler was deeply inspired by this unusual experience. When she returned to her Brazilian home town Porto Alegre, Tessler went to a café every day where she read *Ulysses* in English and Portuguese six times, marking every verb she could find – 4,311 of them. She then used the gerund forms of all these verbs for her installation. Each verb was stamped on a cork and inserted into one of 4,311 empty wine bottles. Additionally, a long wooden drawer, resembling a library file, contains 4,311 postcards with photographs of the River Liffey in Dublin, Ireland, shown along with the different gerunds (eating, loving, breathing, waiting, etc.).

Elida Tessler's works are almost always constructed from words, language, literature, and books. Her imaginative, labour-intensive projects are inspired by legendary authors from the canon of Western literature. She is as fluent in the languages of James Joyce, Marcel Proust, Thomas Mann and T. S. Eliot, as she is familiar with and passionate about Brazilian authors such as Guimarães Rosa and Zulmira Ribeiro Tavares. She translates, transcribes, writes and re-writes key words and phrases, appropriating words from the pages of books and inscribing them methodically on everyday objects such as clothespins, keys, boxes, postcards, and wine corks. With each new project she essentially writes a new chapter in the story of a visual artist who sees beauty in words and shares that beauty by translating written words into visual art.

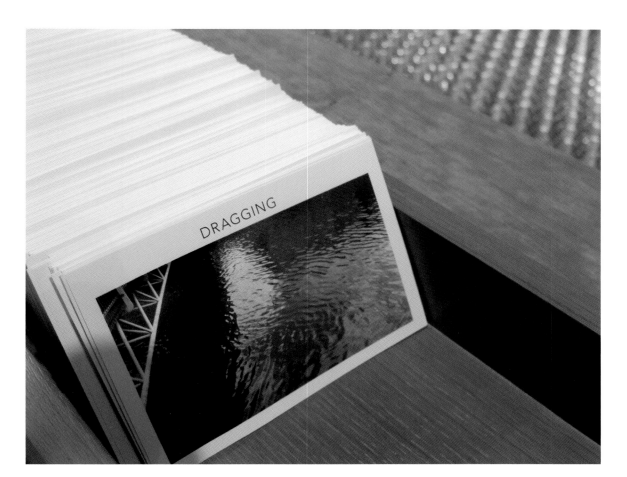

Here and following pages
Elida Tessler
Dubling
2010
Mixed-media installation
Courtesy of CIFO,
The Cisneros Fontanals
Art Foundation, Miami

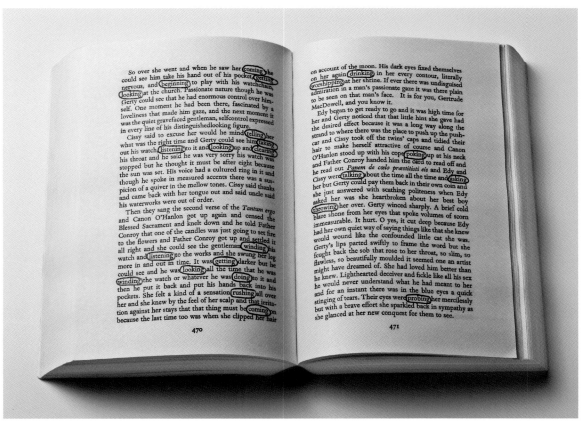

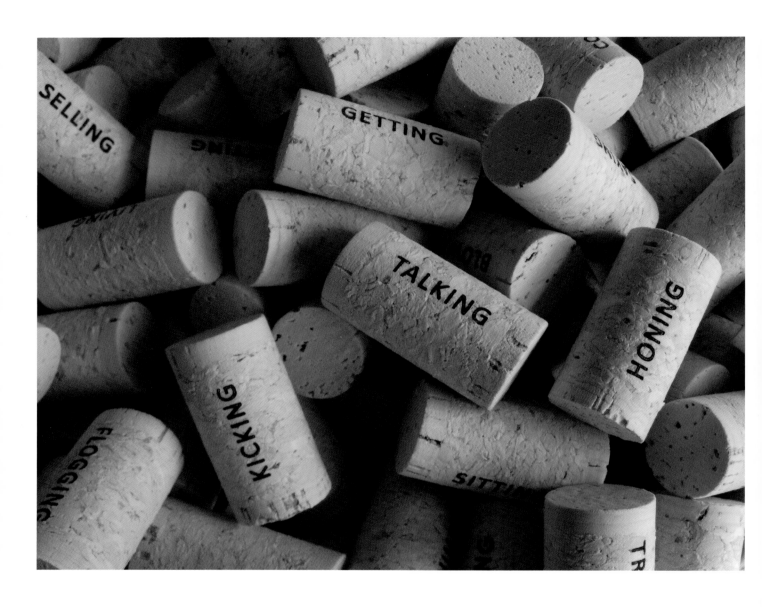

Chapter Ten
A ROOM OF ONE'S OWN

Cristina Lucas

Cristina Lucas' video *You Can Walk Too*, 2006, is a direct reference to Virginia Woolf's *A Room of One's Own*. In the first scene we see a woman lying in bed reading passages from the book: "Sir, a woman's composing is like a dog's walking on his hind legs. It is not done well, but you are surprised to find it done at all."[12] This first sequence is followed by a cinematic, Disneyesque introduction to an idyllic fairy-tale place. Filmed in a remote Spanish village, the setting is the perfect provincial backdrop for a group of dogs that emancipate themselves from their female owners. The fluffy little dogs take us by surprise, as they literally stand up and take control, joining forces with the other dogs, taking to the road to leave their masters and presumably the oppression of this provincial village. The video is a strong metaphor for the denigration of women throughout history, and as also expressed in the canon of literature. The work is a highly witty and refreshingly amusing reference to a specific literary passage, as well as the sexism conveyed through language that prevails throughout literature, even in award-winning, canonised books written by women.

It is important to keep in mind that Virginia Woolf was before her time in regards to her empowering, feminist views, particularly in terms of her thoughts about female creativity. In *A Room of One's Own* Virginia Woolf defines the necessary conditions for creating works of art. She argued that women should have a room of their own, a lock on the door and a stipend each year in order to attain the freedom to speak their mind (and hopefully the ability to leave out what should be left out in order to write better poetry and fiction). Virginia Woolf wrote that books continue each other, in spite of our habit of judging them separately, and Cristina Lucas' video also continues Virginia Woolf's book. The importance of this is punctuated at the end of the video with a final quote from Woolf's book: "So accurately does history repeat itself." While a lot has changed since *A Room of One's Own* was first published in 1929, not enough has changed to make Woolf's thinking seem outdated, which is precisely what makes Cristina Lucas' *You Can Walk Too* so captivating.

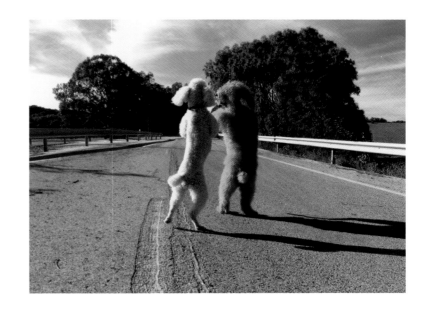

Cristina Lucas
You Can Walk Too
2006
Video
A project of the NMAC Foundation,
Cadiz, Spain

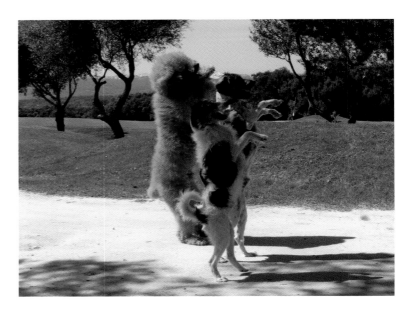

Chapter Eleven
THE DRUNKEN BOAT

Nina Yuen

As an important source of inspiration for Symbolists, Dadaists and Surrealists, the French poet Arthur Rimbaud has also influenced a long line of artists, writers and musicians through history, including Pablo Picasso, Dylan Thomas, Bob Dylan and Jim Morrison. Among his countless poems, *The Drunken Boat* is one of the most famous, and stands as a perfect example of Rimbaud's particular style of poetry, conveyed in a richly symbolic dream-like narrative.

Nina Yuen's 2007 video *Rimbaud* is typical of her playful approach to narrating. Her videos often feature her in the leading role, where she romps about in humorous scenes of dress-up. Her naïve, offbeat style really captures the magic and innocence of childhood fantasies and role-play, conveyed in videos that are as inspired by art history as they are by the canon of literature. She typically narrates her films in a flat, monotone voice that further emphasizes her witty humour. The narrative of *Rimbaud* reads as a short history of the rise and fall of a few of the greatest authors of all time, summing up the careers of Ralph Ellison, Arthur Rimbaud, Paul Valéry and Herman Melville, seemingly in one extended breath, as she acts out each role, using various costumes, props and makeup for added effect:

> I am Ralph Ellison. My first novel *Invisible Man* was a best seller, and more than that it was an art novel, a modernist novel, and it was by a black writer. I had great hopes for my second novel. It was to be a symphonic novel combining voices from all parts of the culture. It grew and grew. I worked on it for forty years until I died in 1994 at the age of eighty leaving behind more than two thousand pages of manuscript and notes … I am Rimbaud, I gave up poetry at the age of nineteen … I am Paul Valéry. I wrote some poetry and prose in my early twenties and then I took twenty years off to study my mental processes … I am Melville. I exhausted my artistic capital in my seafar-

ing years with *Typee* and *Moby Dick*, and then my career petered out.

Alison, 2006, involves a similar approach. As with *Rimbaud*, Yuen plays the dual role of the main character and the narrator. She thereby plays the role of a storyteller while also effectively playing the role of the subject of the story. Personal biography melds seamlessly with strong literary references, creating a rich tapestry of interweaving stories that cleverly combine fantasy with reality, past with present, fact with fiction. *Alison* begins with Yuen who recites a missing persons report that relates to a childhood friend. With the ability of a true storyteller to suspend any inclination towards disbelief, she recounts memories from her own experience weaving them into a storyline that is as indebted to Raymond Carver's love poem *Waiting* as it is to Virginia Woolf's suicide note, both recounted in the video. With deadpan humour Yuen re-enacts Woolf's death by submerging herself in an overflowing antique bathtub. Yet again, Virginia Woolf's words of wisdom ring true, reminding us, once more, that books not only have a way of influencing each other, they also have a way of influencing the most wonderful narratives in contemporary art.

Nina Yuen
Rimbaud
2006
Video

Nina Yuen
Alison
2006
Video

Chapter Twelve
THE CARDBOARD HOUSE

Eloísa Cartonera

Eloísa Cartonera is an artist collective that produces books with hand-painted cardboard covers, primarily based on well-known Latin American literature. They purchase the cardboard from *cartoneros* (urban scavengers) who gather cardboard for recycling. When Argentina's economy collapsed in 2001, thousands of people were forced out of work. Some made a meagre living by scavenging for scraps of cardboard and paper, which could be sold to recyclers. The scavengers became known as *cartoneros* or the cardboard people. Early in 2003, a group of artists and writers came together to figure out a way to help the *cartoneros* earn a better wage or find them a more regular employment. From these beginnings, the alternative publishing house of Eloísa Cartonera was born.

I first came across the Eloísa Cartonera project at the São Paulo Biennial in 2006, where I was completely mesmerised by their unique hand-painted cardboard books. I bought several copies and was anxious to invite them to participate in *The Storytellers*. I sent an email to Eloísa Cartonera; mistakenly thinking that was the name of the artist. I kept the books on my desk as a constant source of inspiration while I patiently waited to hear back from "Eloísa." It was not until I travelled to Buenos Aires for a research trip several years later that fate brought me straight to Javier Barilaro, one of the founding members of the Eloísa Cartonera collective.

The Norwegian Department of Foreign Affairs had scheduled an appointment for me at Galería Braga Menendez in the Palermo/Soho district of Buenos Aires. Two minutes after I walked in, I saw a colourful, vibrant painting by Javier Barilaro that immediately caught my attention. Florencia Braga Menendez was delighted to hear of my interest in his work, and explained that he was part of the Eloísa Cartonera artist collective. I couldn't believe it. When I told her that I had been trying to contact Eloísa Cartonera for quite some time, she responded with laughter and excitement. In typically gracious Argentine manner, she cancelled all her subsequent appointments so that she could introduce me to Eloísa Cartonera's most avid collector, and Javier Barilaro himself. Along the way, we stopped by countless galleries and studios, so it was way past 10 pm before we arrived at the collector's house. There I discovered not only a few Eloísa Cartonera books, I found an entire Eloísa Cartonera library, with some of the most beautiful little books imaginable.

During the course of a long and delicious gourmet dinner, the more wine we enjoyed, the more we were all touched and inspired by all the serendipitous details. After dessert Florencia suggested that we drop in on Javier who was busy painting a mural in a café/nightclub. It was already well past 1 am, so I was a bit worried that this part of the adventure might bring me to the exact opposite side of sprawling Buenos Aires in the dead of night, but decided that I had to follow this story to its end. Imagine our surprise to discover that the café where Javier was painting his mural was located exactly next door to the hotel where I was staying. Such a fortuitous alignment of the stars, fate, chance, and serendipity is straight out of a magical realist novel. It was clearly meant to be.

Chapter Thirteen
UNPACKING MY LIBRARY

Ryan Brown

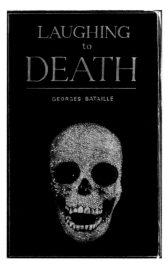

Here and opposite
Ryan Brown
Collection # 4 (Either/Or)
2010
Acrylic, graphite, watercolour, ink
and glitter on paper on wood
Courtesy of the Zabludowicz
Collection, London

Ryan Brown's various book collections can be described as an interpretation of the landscape of the bookshelf. He creates small collections of books (painted objects) with the respect of a bibliophile, and with the diligence of an adept painter. Based on the premise that "we are what we read," one can find out a lot about a person looking at the books in his/her bookshelf. Formally speaking, the different sizes, shapes and colours of the books in a bookshelf create interesting patterns, varying from the highly methodical and meticulously categorised to the completely unstructured. Of course, it is the actual topic of the books that tell the most about a person, their interests, their background, and their passions. The books typically included in Ryan Brown's installation pieces are clever adaptations of seemingly well-known art historical and theoretical books, ranging from *Goya* to *Grey's Anatomy*, to Bataille's *Laughing to Death* (actually a non-existent book, but one that seems probable). Each book is painstakingly and precisely executed to the extent that they look like real books even upon close examination. In fact, these are books without words, but their meaning is anything but empty. If we were ever to read a book by its cover, this would be an ideal time to do it.

Walter Benjamin immediately comes to mind in relation to Ryan Brown's work. As an artist who makes collections of books, to be read and understood as art, Brown takes on a complex role that is easily understood within the context of Benjamin's thoughts about book collecting. It should be noted that Brown not only collects books in the strictest sense of the term, he creates books, and even more importantly, copies of books. The pleasure of book collecting as it comes alive in Walter Benjamin's essay "Unpacking My Library," is also conveyed in Ryan Brown's *trompe-l'œil* books:

Not only books but also copies of books have their fates. And in this sense, the most important fate of a copy is its encounter with him, with his own collection. I am not exaggerating when I say that to a true collector the acquisition of an old book is its rebirth. This is the childlike element, which in a collector mingles with the element of old age. For children can accomplish the renewal of existence in a hundred unfailing ways. Among children collecting is only one process of renewal; other processes are the painting of objects, the cutting out of figures, the application of decals—the whole range of childlike modes of acquisition, from touching things to giving them names. To renew the old world—that is the collector's deepest desire when he is driven to acquire new things.[13]

Not only do the books on Ryan Brown's shelves signal a rebirth, the books are so realistically created that even the frayed and torn edges, faded price stickers, and other signs of age are convincingly executed, conveying the unique charm of old books over new books. Anyone who really loves books should almost be able to detect the sweet smell of the imaginary pages inside. Walter Benjamin's description of a child's unique ability to accomplish the renewal of existence, through collecting and painting in particular, is powerfully conveyed in Ryan Brown's approach. It is worth noting that Ryan Brown has not only created a collection of books, he has also made shelves for the books. As Benjamin says, the true freedom of books lies somewhere on the book collector's shelves. So, with books as the building stones of this work let us disappear inside, and discover what makes a book collector tick.

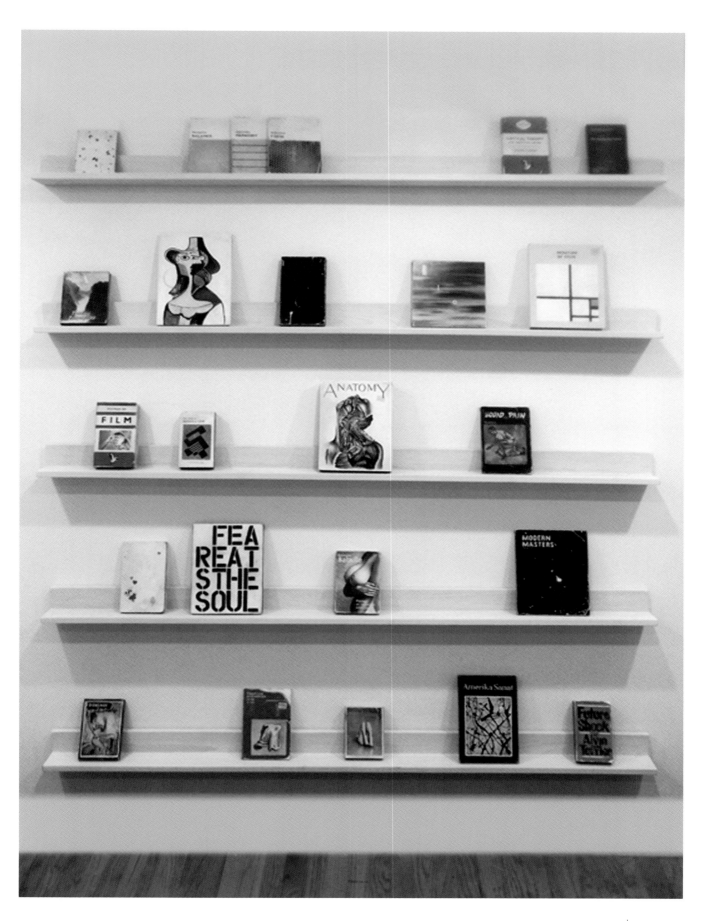

Chapter Fourteen
LOVE IN THE TIME OF CHOLERA

Valeska Soares

In the incredibly vast and populous country of Brazil it always amazes me to discover how the stories of the different artists I meet invariably seem to unfold in relation to one another. The premise of John Guare's Pulitzer prize-winning play *Six Degrees of Separation* certainly proves true in Brazil, at least when it comes to the artists in *The Storytellers.* The possibility that Valeska knows Elida, who knows Fabio, who knows Marilá, who knows Eder, who knows Cao might even be a story of its own. Of course, the story about Brazilian visual artists who are inspired by literature, books, poetry, prose and words was written years ago, and that is what links these artists together. Valeska Soares' projects typically play with the boundaries between knowledge and perception, conveyed through an understated, minimalist aesthetics that leaves us in an equally playful and pensive state.

Love Stories is an ongoing project that includes books that contain the word love—in five different languages—in their titles. Even without titles, we can easily imagine the books that fill these shelves. While there has been no lack of love in modern literature,

with the exception of Gabriel García Márquez' *Love in the Time of Cholera*, there are few great literary works that actually include the word "love." This is only part of the beauty of the hundreds of books found on the shelves of Valeska Soares' work. She dares to embrace the most sentimental topic of literature, and simultaneously avoids referencing any of the most iconic love stories of all time. Her approach prioritises the word "love," above the actual love story relayed in a book. I find poetic beauty in the fact that this book project is a cool, understated, nearly minimalist interpretation of a highly clichéd, emotional topic. While Soares' work speaks about a recurring theme throughout literature, even more importantly it is open for interpretation. Soares does not reinterpret what has been written, she strips it completely of meaning and content, hinting only at the original language of the books (as understood in the various colour codes of the books), ultimately allowing us to project our own stories onto the blank pages of books whose origins and stories we will never gain real access to.

Valeska Soares
Love Stories V
2008
500 books, 5 sets of 100: 1 in
Portuguese, 1 in English, 1 in Spanish,
1 in Italian and 1 in French
Private collection, São Paulo

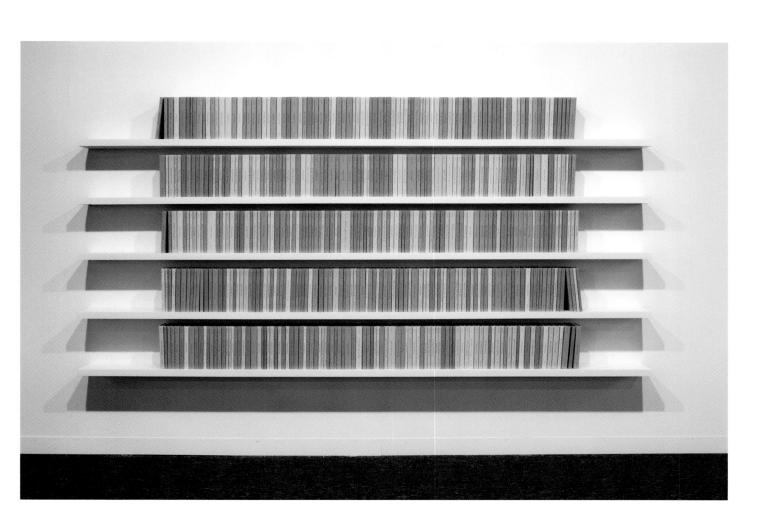

Chapter Fifteen
THE BOOK THIEF

Georges Adéagbo

Through his unique, site-specific installations, Georges Adéagbo seeks to investigate the mysteries underlying the evolution and destiny of a person, a city or a country. This often means tracing as many as several hundred aspects, each represented by an object, to reveal the various forces that combine to form a particular culture. It should be noted that Georges Adéagbo does not consider himself an artist. Instead, he stands apart from the art scene, describing himself as an observer, one who thinks about and tries to find solutions about various aspects of our present world. He creates a bridge between races, and reveals universal similarities between cultures as he seeks to serve as a catalyst for mutual understanding. Adéagbo expresses his insights through installations that are typically comprised of a combination of found objects, commissioned paintings and carvings, books, articles, and original texts.

The stories that are woven throughout Georges Adéagbo's work relay the universal stories of life, touching upon history, politics, culture, music, art, and literature. What Adéagbo does with the books, magazine articles, handwritten notes, pictures, debris, clothing, shoes, sculptures, paintings, postcards, and posters is most certainly an artful interpretation of the world we live in. I can't imagine anyone who wouldn't consider Georges Adéagbo an installation artist in the best sense of the term. He keeps telling me he isn't, which is part of the magic of his work. If he isn't an artist, what exactly is he? Adéagbo employs numerous expressive modes in his work, including the multiple roles of observer, philosopher and collector. He is a storyteller who melds found objects with his own writing to make insightful cultural observations. Georges Adéagbo is a thinker who brings together his impressions from each day. He is a creative force who is equally drawn to written words and visual details. Although his writing punctuates his installations with personal anecdotes and observations

about people he meets or projects he is working on, he is almost equally reluctant to call himself a writer. It wasn't until I realised that Adéagbo is a true storyteller that I finally came to terms with not calling him an artist. Once upon a time there was a man from Benin who was wise beyond his years, observant and sensitive to the world around him. He saw and understood what others might overlook. He was patient and he was quiet. He was what many might think of as a sage. This man was humble, polite, soft-spoken and patient. Above all, this man was aware. He was aware of the inherent magic of placing various objects together to create large-scale site-specific installations. He found beauty all around him, in the most unlikely places, always aware of how they might fit in to his next big project. Once upon a time there was a man from Benin who travelled the world creating magic and wonder everywhere he went, from Venetian bridges and apartments to important museums worldwide, he brought together the various impressions from his experience and perspective of the world as one might put together a scrapbook. Once upon a time there was a man from Benin who told stories relating to the history of Benin, complemented by a love story or two, punctuated by philosophical reflections about life and numerous references to various news headlines, always making sure to include used books that convey a real sense of timelessness and meaning. This man is Georges Adéagbo.

Georges Adéagbo
Un espace...! Monde (histoire de l'art)
2001
Installation shots from Kunsthalle Zurich
Courtesy of Stephan
Köhler/jointadventures.org
http://jointadventures.org

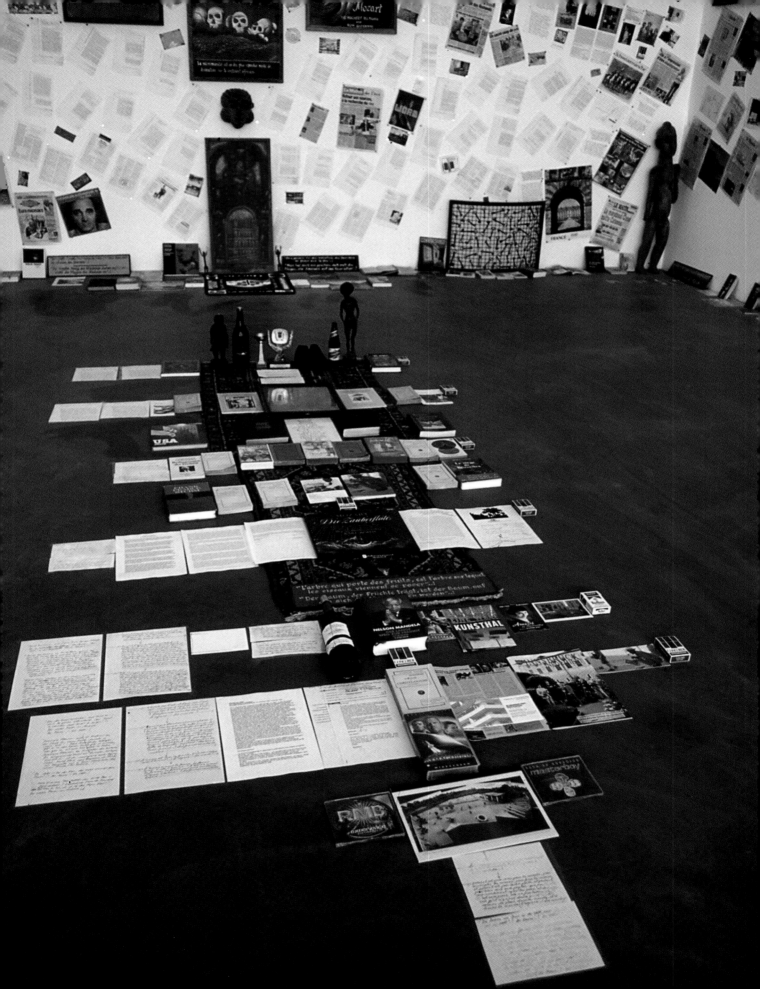

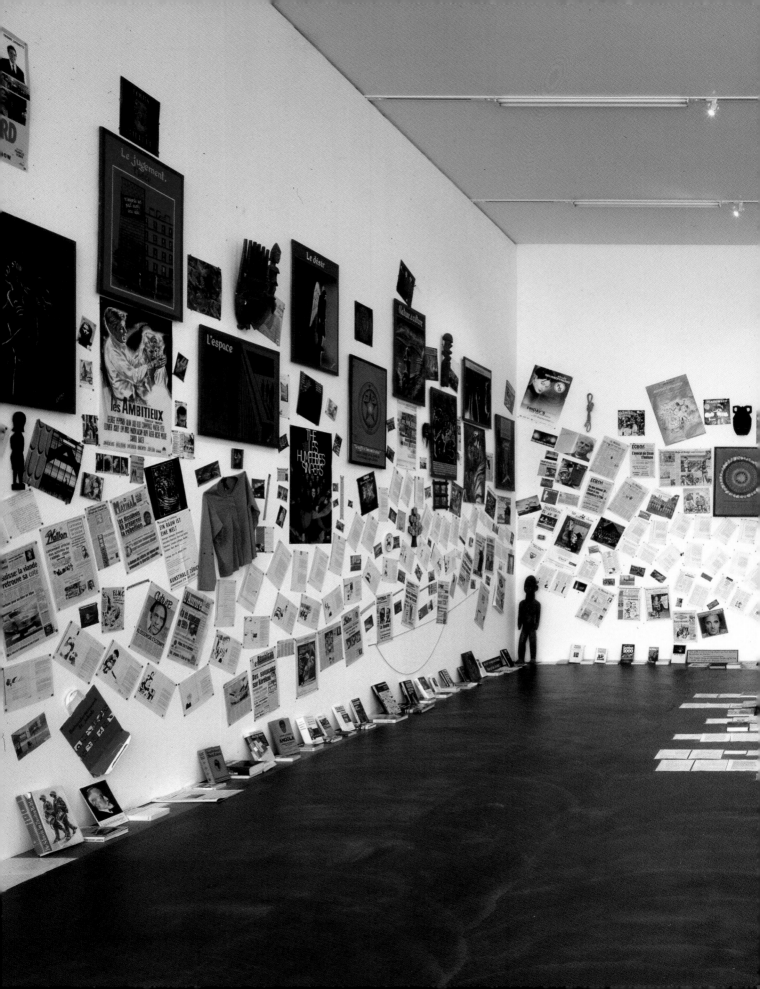

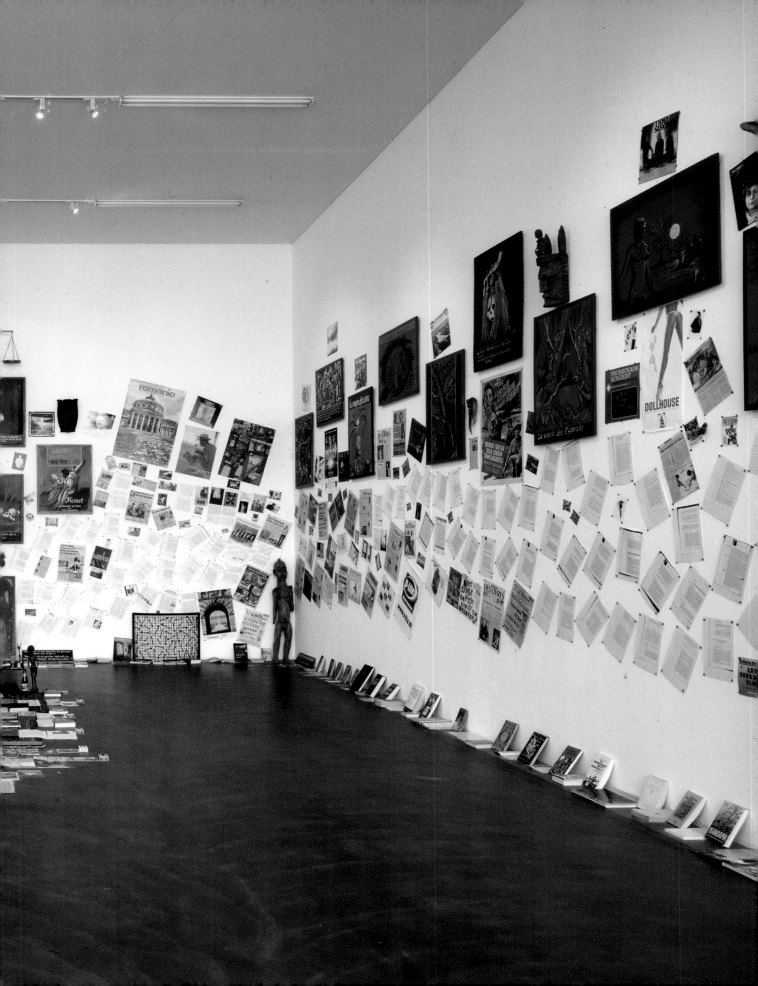

Chapter Sixteen
EXTREMELY LOUD AND INCREDIBLY CLOSE

Mónica Bengoa

I can't imagine a more suitable reference to Mónica Bengoa's work than the title of Jonathan Safron Foer's critically acclaimed novel. Although there is no real connection between Foer and Bengoa, no thematic parallels, nor significant underlying meanings, these words insist on being appropriated as the title of this chapter. The colour and scale of Bengoa's work is, in fact, extremely loud, and her visual vocabulary is meticulously crafted from an incredibly close perspective.

Bengoa is renowned for her large-scale wall installations that are highly indebted to process-oriented art and craftsmanship. For *The Storytellers*, Mónica Bengoa presents her new installation *Einige Beobachtungen über Wildblumen: Bienen-Ragwurz (Ophrys apifera) und Schachblume (Fritillaria meleagris) or Some Considerations on Wild Flowers: Bee Orchid (Ophrys Apifera) and Chess Flower (Fritillaria Meleagris)*. This work is a mural of pierced felt executed strictly in varying shades of red and orange. Using her camera from an extreme angle, Bengoa takes a close-up photograph of a page from an encyclopaedia, and recreates exactly what the camera has captured, including the variances in blurriness and focus. The end result is that some letters, words and images are completely obscured whereas others are perfectly clear.

This installation fits beautifully into *The Storytellers* context, particularly in terms of the relevance of the encyclopaedia throughout history as the single most important book for learning about topics ranging from history and culture to philosophy and science. Of course, the words and pictures in an encyclopaedia do not tell stories, they convey facts, something that may seem at odds with the premise of *The Storytellers*. Although I do know more than a few intellectuals who methodically read them as if they were novels, encyclopaedias can hardly be classified as literature. Nevertheless, an understanding of words as defined in encyclopaedias and dictionaries is an absolute necessity for authors and readers alike, integral to absolutely all literature, poetry and prose.

Taking a step back to discover the details in Mónica Bengoa's installation, I am struck that her approach to words and language involves an inherent deconstruction of meaning in the translation of factual scientific words into abstraction. The blurry traces of text and letters read as distorted words that speak loudly about the transition from written to visual language. Ultimately, Bengoa's larger-than-life encyclopaedia captures the power of knowledge to change our perspectives of the world we live in, in this case, as specifically related to science and nature.

Mónica Bengoa
Einige Beobachtungen über Wildblumen: Bienen-Ragwurz (Ophrys apifera) und Schachblume (Fritillaria meleagris) or Some Considerations on Wild Flowers: Bee Orchid (Ophrys Apifera) and Chess Flower (Fritillaria Meleagris)
2011
Wool felt cut out by hand

Chapter Seventeen
STORIES OF SEEING

**Lobato
& Guimarães**

Lobato & Guimarães film *Accident*, 2006, is best described as a cinematic poem about twenty cities in the State of Minas Gerais, Brazil. This poem is also a story, and the story being told is the story of life, as conveyed in a rich visual vocabulary that is punctuated throughout with the sounds of music and conversation. The series of vignettes that make up this film capture the simple beauty of life, as well as the struggles of life. Absolutely everything about the film is poetic, including the evocative names of towns such as Watery Eyes and Between Leaves. Each scene conveys the quiet, understated beauty of the dusty corners of rural Brazil. Each individual vignette is a visual poem in its own right, and these poems weave in and out of streets and rivers, between day and night, balanced between public and private, inside and outside. The title highlights the unpredictability of life, and emphasizes the fact that much of what was filmed happened by chance. Playing with the title of Cao Guimarães' book *Stories of Not-Seeing*, one could say that these are "stories of seeing."

The sounds of a thunderstorm on a dark night and noisy cars driving by are offset by the quaint sound of church bells and crickets. Children laugh and play on a street corner as they wait for a religious procession to begin. The simple activities of daily life are expressed in an almost painterly approach to moving images, perfectly punctuated by music, conversation and laughter. A close-up of a bicycle wheel patiently lingers on the screen. A pair of plastic cups dances slowly on a colourful tile floor. Two red straws shout out to be used. A set of weights in a gym has the presence of a sculpture. These scenes are shot like photographs that exude a sense of peace and calm and provide a welcome counterpoint to the activity that plays out elsewhere. We hear fragments of conversations, instruments being played, we see people walking slowly along the streets, busy working or just busy breathing and living.

Chapter Eighteen
JOURNEY TO THE MOON

William Kentridge

Among the many storytellers in this exhibition, William Kentridge is among those whose approach does not involve a direct reference to an already existing literary narrative. *Journey to the Moon*, 2003, is a classic example of Kentridge's signature style, where charcoal drawings come to life in a playful, almost surreal narrative. Neither a story retold or re-interpreted, the film conveys a story that is entirely his own. Kentridge describes the work as an attempt to escape, and as viewers we cannot help but escape the weight of reality as we enter the magical world of his imagination—a world that is as captivating as the most visual storybook. *Journey to the Moon* is as inspired by the magical realism of the French filmmaker Georges Méliès, as it is indebted to the science fiction style of Jules Verne, yet it is only loosely related to Méliès' famous 1902 film *Le voyage dans la lune*. The most distinct similarities are found in the gentle sound of a piano playing in the background, the iconic moon that is featured midway through Méliès' film, and the general plot of building a rocket to escape to the moon. Yet, Kentridge's film is more than a tribute to science fiction or a clever play with cinematic effects, as best described in Kentridge's own words:

A bullet-shaped rocket crashes into the surface of the moon; a fat cigar plunged into a round face. When I watched the Méliès film for the first time at the start of this project, I realised that I knew this image from years before I had heard of Méliès. I was far advanced in the making of the fragments for Méliès. I had resisted any narrative pressure, making the premise of the series, what arrives when the artist wanders around his studio. What arrived was the need to do at least one film which surrendered to narrative push. The various props accumulated in the six weeks of making the other fragments threw themselves forward. The espresso pot and cup from *Tabula Rasa* became respectively the rocket ship and telescope, the rubbed-out landscapes from *Moveable Assets* the basis for the moon landscape, the reversed catching skills from *Auto-Didact* the metaphor for weightlessness, and the dark shape that becomes the window of the rocket was one of the messy sheets of *Tabula Rasa II* ("good housekeeping") which perforce meant the inside of the studio was the inside of the rocket. Méliès' moon is of course a late nineteenth-century colonial moon, an image of difficult terrain and savages. My lunar landscape is Germiston, just outside Johannesburg; in effect the same landscape from which the rocket takes off. In my head while making the film, there was inescapably Jules Verne's book (which I don't think I have ever read but for which I have seen illustrations), *2001 A Space Odyssey*—there is a momentary reference to this—the Wallace & Grommit film, *A Grand Day Out*, and of course Méliès. It strikes me now that he also uses live performers as planets and stars; although my ants were smaller and more numerous than his showgirls. If the seven earlier fragments are about wandering around the studio waiting for something to happen, *Journey to the Moon* was an attempt to escape. Méliès' hero returns to a civic celebration; mine is still stuck in his rocket.

Opposite and following pages
William Kentridge
Journey to the Moon
2003
Courtesy Goodman Gallery, Johannesburg

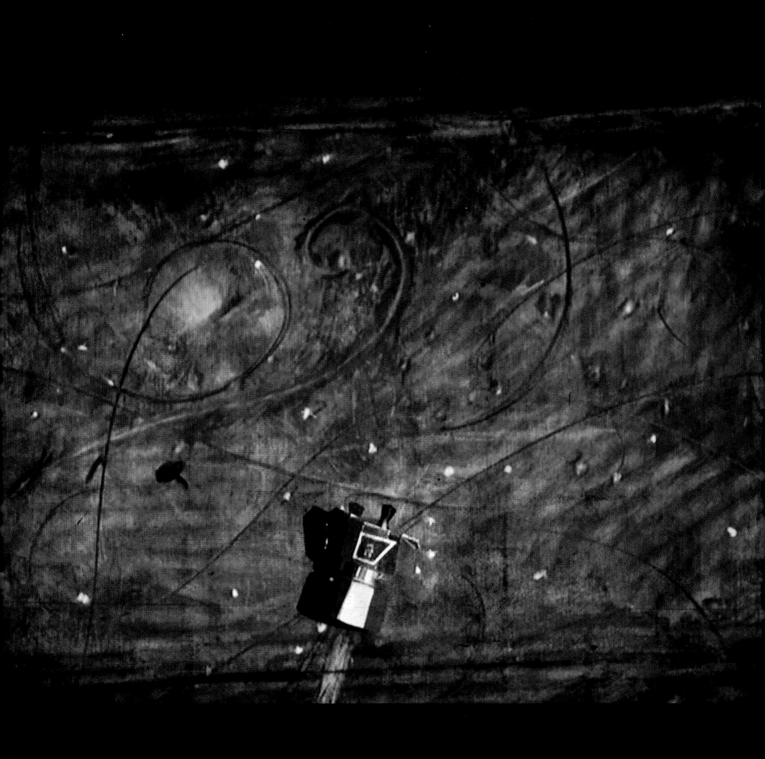

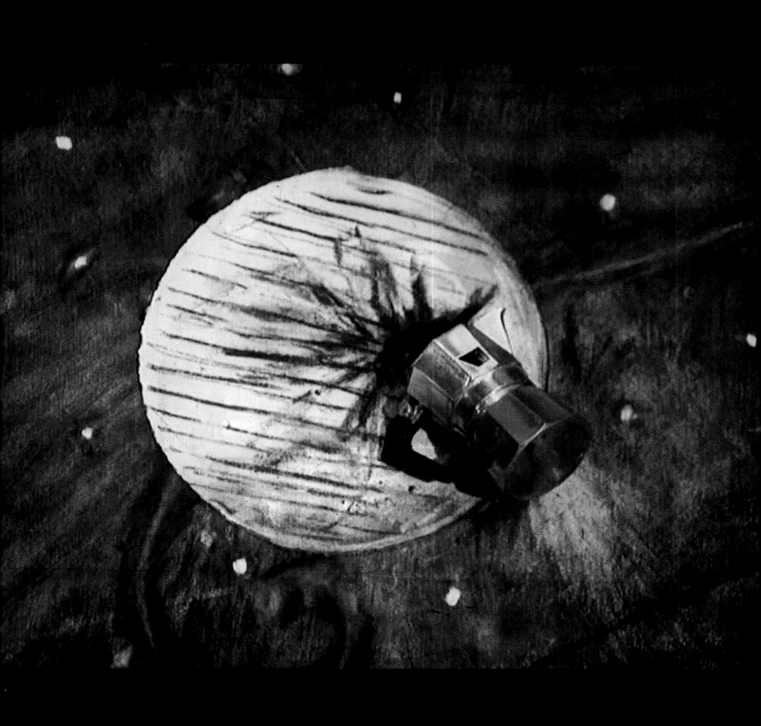

Chapter Nineteen
IN THE TIME
OF THE BUTTERFLIES

Fabio Morais

I first encountered the work of the Brazilian artist and writer Fabio Morais in the 2010 São Paulo Biennial, where he collaborated with Marilá Dardot to create the wonderful large-scale installation *Far Away, Right Here*. The relationship between words and pictures, as seen in conceptual projects that include books as a source of inspiration for visual art, defines the work of both of these artists. This major installation was an actual house with a labyrinthine interior, filled with many rooms and narrow passageways that lead up to a large central space. The walls, doors and carpets of this house of literature were decorated with images of the books that these artists often reference in their work.

Quite fittingly, the house contained a library with hundreds of books sent in by artists from all over the world in response to an open invitation from Dardot and Morais, in response to the question "What books would you build your house with?" References to great authors such as Calvino, Rimbaud and Borges abound, and the diffuse, surreal quality of their writing in particular provides the perfect imaginary foundation for a house that pays tribute to the magical power of books.

Throughout his work, Fabio Morais investigates the deconstruction of language and plays with the mapping of text and image to construct a visual vocabulary that relates to memory, language and identity. Frequently using writers, poets and critics as the basis of his works, Morais appropriates text, language and image and uses them as a place of negotiation between artist and spectator. For the exquisite piece *Migracão*, 2006, Morais transformed books into small sculptures, carving out impressions of butterflies from each of the books. Meaningful text disappears in favour of a strong visual image. The powerful and immediately recognisable shape and form of the butterflies turns these books into small treasures. These are art books in the best sense of the term, books that prioritise sign over language, image over word. What we see and what we might be able to read in these sculpted books translates as a captivating metaphor relating to books as an endless source of inspiration and wonder.

Fabio Morais
Migracão
2006
Books sculpted as butterflies
Private collection, Bogota

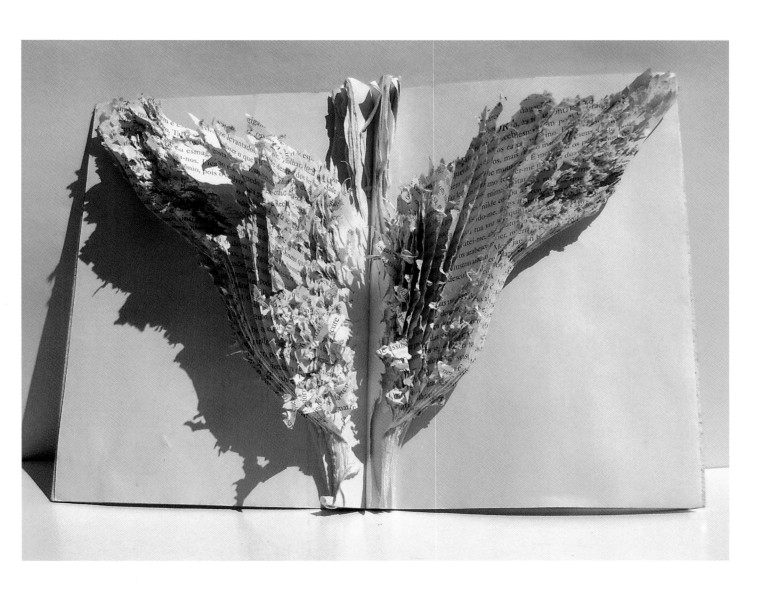

Chapter Twenty
THE DEVIL TO PAY IN THE BACKLANDS

Eder Santos

At the most basic level, what defines a great story is that it can be told and retold countless times without ever losing its power. We all know the pleasure of picking up a book from the shelf to re-read it years and even decades later. Rewards are found with each new reading of a treasured book. The experience of re-reading a book signals a return to the past and a search for new meaning. This is something that Eder Santos seems to be well aware of. For his participation in *The Storytellers*, he decided to revisit a story that made a deep impression on him early in his career.

Eder Santos' 1993 film *Janaúba* is inspired by a book by the legendary Brazilian author Joao Guimarães Rosa—*Grande Sertao: Veredas*, loosely translated into English as *The Devil to Pay in the Backlands*. Santos consistently creates vibrant, poetic works that merge personal experience, cultural observation and technical proficiency as a means of expressing themes that are central to Brazil's African, indigenous and European heritage. With a gift for evoking the rhythms and textures of memory and history, he knows all about the power of moving images to tell stories that deserve to

be retold. *Janaúba* is a narrative film inspired as much by poetry and literature as it is by basic "life stories." Picking up the thread of this legendary story once again, nearly twenty years later, Santos integrates *Janaúba* into a new installation context that will ultimately provide a fresh perspective on the original story.

Joao Guimarães Rosa was one of the greatest Brazilian novelists of the twentieth century, and is often referred to as the James Joyce of Brazil. *The Devil to Pay in the Backlands* is a hauntingly poetic journey through time place, culture and memory. This is precisely what Eder Santos' film captures, coupling iconic film footage of a horseback rider with a mesmerising soundtrack and excerpts of text that intermittently fill the screen. The slow, almost painful beauty of this film reads as a haunting journey through the hostile backlands of Minas Gerais, where existential questions linger in the dust. Guimarães Rosa's tale is a truly legendary story that involves a search for meaning and a longing for understanding, and a quote from his writings sets the tone for our encounter with *Janaúba*: "The master is not one who teaches; it's the one who suddenly learns."

Eder Santos
Janaúba
1993, version 2012
Multimedia installation

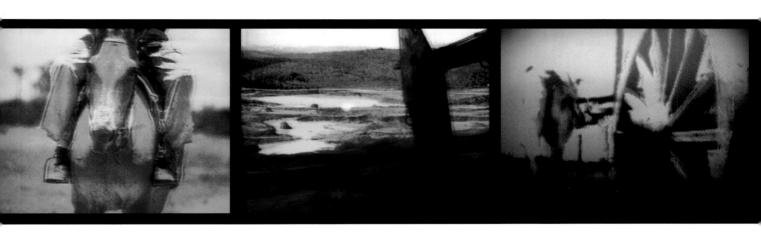

Chapter Twenty-One
THE PALM-WINE DRINKARD

Maria Magdalena Campos-Pons

When Maria Magdalena Campos-Pons read the Spanish translation of Amos Tutuola's book as a young girl in Cuba, she was particularly touched by his description of trees. The story literally rooted itself in her memory, providing a fertile seed of inspiration that has blossomed throughout her work. Drawing on the West African Yoruba oral folktale tradition, Amos Tutuola's story describes the fantastic, nightmarish odyssey of a palm-wine drinker. Deeply inspired as she is by her ancestral roots, it makes sense that Campos-Pons was inspired by the masterwork of one of Nigeria's most influential writers.

While Campos-Pons' life story is entirely unique, it also conveys the particularities of the collective Diaspora experience. Fittingly, she describes the story conveyed in *Rooted*, 2012, as part African legend, part Campos-Pons fairy tale. Returning again to Walter Benjamin, his words read as an apt description of Campos-Pons' specific approach to this work in particular. Benjamin writes: "All great storytellers have in common the freedom with which they move up and down the rungs of their experience as on a ladder."[14] Throughout her career, Campos-Pons has moved back and forth, up and down, between here and there, constantly navigating the landscapes of her mind that are equally rooted in Cuba, Nigeria and the United States. She is influenced by memory and driven by dreams that consistently translate to a rich visual language that has no boundaries. Equally comfortable with almost every medium, she has been conveying various aspects of her story for years, expressed in performances, interventions, video works, installations, photography, and works on paper.

Maria Magdalena Campos-Pons is most definitely a storyteller, but perhaps even more importantly she is also a fairy-tale teller. Benjamin's reflections on the teller of fairy tales convey the real significance of this aspect of her work:

The first true storyteller is, and will continue to be, the teller of fairy tales. Whenever good counsel was at a premium, the fairy tale had it, and where the need was the greatest, its aid was nearest. This need was created by the myth. The fairy tale tells us of the earliest arrangements that mankind made to shake off the nightmare which the myth had placed upon its chest … The wisest thing—so the fairy tale taught mankind in olden times, and teaches children to this day is to meet the forces of the mythical world with cunning and with high spirits.[15]

In a recent conversation with Maria Magdalena Campos-Pons, she described aspects of her artistic approach that serve as a perfect introduction to *Rooted*. This is the description of a young girl who found freedom in books; this is the story of an artist who would someday become a storyteller in her own right:

My sensibilities lie between the complex and luxurious grandeur of Cuban architecture, the voluptuousness of Cuban curvilinear furniture, beautiful women and suave men walking in the hustle and bustle of the city, as contrasted to the austerity and rigour of the blue of the ocean horizon on a calm day, or the flatness and rationality of a sugarcane field. As a girl I wandered in the *guardarrayas* (sugarcane fields) not knowing yet I was walking within a grid, but I loved the pattern and simplicity of the walls of delicately moving green sugarcane all around me, and the straight, red dusty path I was walking on. This was the place where I found relief reading Rilke, Thomas Mann, Chinua Achebe and Kant.[16]

Maria Magdalena Campos-Pons
Warrior Reservoir
2011
Mixed-media work on paper
Courtesy Vanderbilt University Fine Arts
Gallery, Nashville, Tennessee

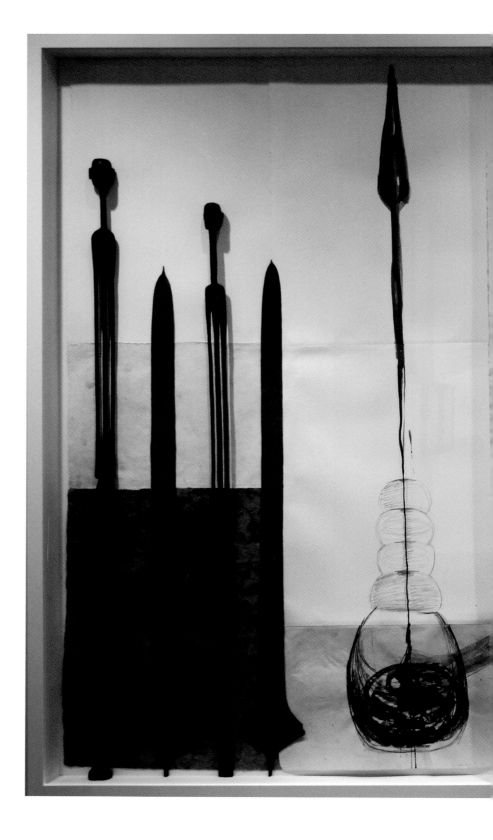

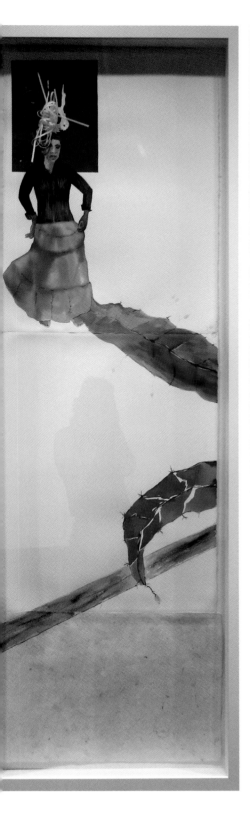
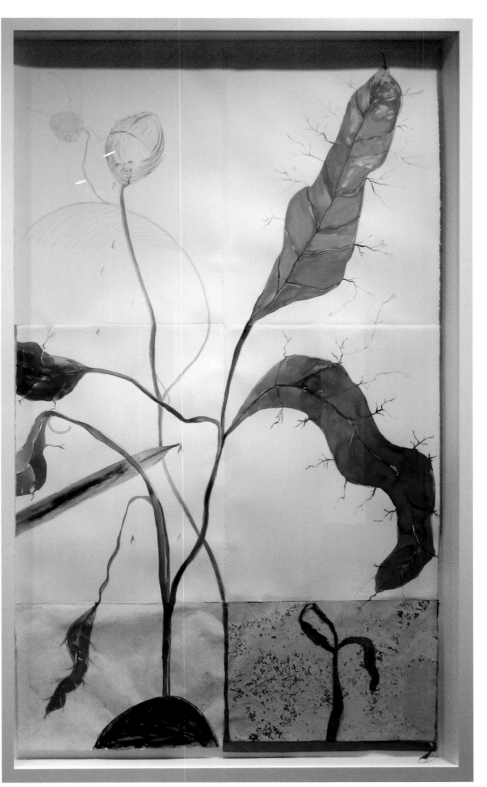

Chapter Twenty-Two
NINETEEN EIGHTY-FOUR

YOUNG-HAE CHANG HEAVY INDUSTRIES

Welcome to the digital age, where quiet paperbacks with faded pages struggle to compete with the fast-paced stories that are being told on television, computers, iPhones, Kindles, iPads and the like. Even though George Orwell saw it all coming, it still comes as a shock. As someone who is obviously still completely in love with the romantic, physical qualities of an actual book I almost felt like I was cheating on my books when I discovered the work of the artist duo Young-hae Chang and Marc Voge, commonly known as YOUNG-HAE CHANG HEAVY INDUSTRIES.

Using Flash animation, YOUNG-HAE CHANG HEAVY INDUSTRIES creates fast-paced, text-based video works that are synchronised with original musical scores. Watching their videos is a fairly intense experience that involves being bombarded with words and music, presented as short, witty texts featured on monochromatic backgrounds. They weave complex narratives throughout work that often references well-known authors or literary styles. Their imaginative and often political narratives offer layered and compelling stories, short stories about life, love, loss, drama, and excitement that inspire us not only to question various aspects of the society we live in, but to laugh about them even as we become aware of the existential questions that run throughout the work. Words literally come to life and dance across the screen, flashing before our eyes in carefully measured time segments that create drama and suspense. YOUNG-HAE CHANG HEAVY INDUSTRIES takes language out to play, and have fun with the size, shape and movement of each and every word. The visual effect is heightened by the specific choice of music, ranging from cool jazz to tango and just about every kind of music in between. If Woody Allen were a visual artist, I think this is exactly the kind of smart approach to art and literature that he might come up with. The sharp humour and weighty cultural references alone are certainly enough to bring Woody Allen to mind. Needless to say, I was delighted when YOUNG-HAE CHANG HEAVY INDUSTRIES suggested creating a new work for *The Storytellers*. Considering how much they seem to enjoy the Norwegian letter Ø, I wasn't entirely surprised that they might be interested in flirting with the letters Æ and Å too. As we go to print, A NORDIC NEUROTIC is a story yet untold, but I just know that it is going to be yet another masterpiece of digital literature. Appropriating directly from *Samsung*, one of their earlier works, this seems like the perfect time to say LØVE. AMØUR. THE END.

YOUNG-HAE CHANG HEAVY INDUSTRIES
A NORDIC NEUROTIC
2012
Original text and music soundtrack,
12 min (approx.), HD QuickTime movie

AS YOU LEAVE
THE STATION
IT STARTS

TO RAIN.
PEOPLE

STAND INSIDE THE
STATION DOORS OR
RUN FOR A FREE
TAXI. YOU HEAD

FOR THE STATION
CAFÉ. YOU SIT,
WAIT, WAIT SOME
MORE, AND,

WOULDN'T
YOU KNOW
IT, NO ONE

SERVES YOU.
TYPICAL.

IS IT
A SELF-

SERVICE
CAFÉ? NO,
IT'S JUST

THE CLASSIC CASE
OF THE WAITER IG-
NORING THE CLIENT.
AND THE CLIENT
JUST HAPPENS TO BE

YOUR-
SELF.

YET AGAIN,
DAMMIT --

HEY,

EASY
DOES IT,

DON'T GET
STARTED.

Notes

[1] Walter Benjamin, "The Storyteller," in idem, *Illuminations* (London: Pimlico, 1999), p. 86. Essay originally published in 1936, first translated into English in 1968.

[2] Ibid., pp. 90–91.

[3] Excerpt from a lecture by Jacques Rancière that was originally presented at the opening of the fifth international summer academy in Frankfurt on August 20, 2004. In a revised form it is published in *Artforum*, XLVI, no. 7 (March 2007).

[4] Jorge Luis Borges, "The Circular Ruins," in *Labyrinths* (London: Penguin Modern Classics), 2000, pp. 74–75.

[5] "Understanding the Expansion of the Universe. An interview between Ernesto Neto and Caroline Menezes," *Studio International* (UK, September 2010).

[6] Virginia Woolf, *A Room of One's Own* (London: Penguin Books, 2004), p. 126. Originally published in 1928.

[7] Gabriel García Márquez, "The Handsomest Drowned Man in the World," in idem, *Collected Stories* (London–New York: Penguin Books, 1996). Originally published in 1968.

[8] Octavio Paz, *The Labyrinth of Solitude* (London: Penguin Books, 1985). From the essay "The Dialectic of Solitude," p. 195. Originally published in 1961.

[9] Ibid., p. 212.

[10] This relates to a lecture that Alfredo Jaar gave on the occasion of the opening of *The Marx Lounge* at the Stedelijk Museum. The full lecture can be seen on YouTube.

[11] Sergio Vega's artist statement.

[12] Woolf, *A Room of One's Own*. Cited from page 63, which is in turn a reference by Virginia Woolf to Cecil Gray's book, *A Survey of Contemporary Music*.

[13] Walter Benjamin, "Unpacking my Library", in idem, *Illuminations*, p. 63. Essay originally published in 1936, first translated into English in 1968.

[14] Benjamin, "The Storyteller," pp. 100–01.

[15] Ibid., p. 101.

[16] Quoted from a conversation between Maria Magdalena Campos-Pons and myself in July 2011.

ESSAYS

TELLING STORIES

Mario Vargas Llosa

Making up and telling stories is as old as the spoken word itself, a pastime that must have been born with, and grown up with, language. It all started with simple grunts and groans, with hand gestures and pulling faces; from this, our ancestors, those primitive beings who were no longer apes, but were not yet fully human, began to exchange words and understand each other with the aid of a basic code of meaning which, over time, would become more and more subtle, until it reached the most profound levels of complexity.

What stories did they tell, those bipeds back then at the dawn of time, on those long nights full of fear and amazement, sitting around the campfire beneath the gleaming stars? They told stories about things that happened to one or other of them in their desperate day-to-day struggle for survival: the surprises that their traps sometimes held when, instead of the expected deer or monkey, they would find themselves faced with a tiger or a lion. They told stories about other beings that would sometimes appear, who seemed to be human, like them, but did not speak in the same way, nor paint themselves with the same colours and drawings, nor hunt with the same weapons. They told each other stories about things that happened to them; but retelling these events in words did not produce the accurate representation of the events that the stories were intended to tell; rather, the facts were altered by language, by exaggeration and by the vanity of the storyteller, distorted by flights of imagination and by gaps in their memory. But they also told each other stories about things that did *not* happen or, rather, things that only happened in the impalpable and secret world of instincts and desires, of dreams and yearnings—they told of longed-for pleasures and excesses, impossible adventures, feared apparitions and miracles.

Why did they do this? Because making up and telling stories was the best way to enrich the miserable lives they led, to give some kind of answer to the endless questions that troubled them. And because letting oneself become bewitched by a story was, for them, a distraction, a form of magic that, for a brief moment at least, took their minds away from the fear, uncertainty and infinite dangers that made up their daily existence.

Those stories enriched their lives, and shone light into the darkness of their ignorance; the ghosts that haunted them were brought fully into view, and their dreams came to life. For reality, back then, was confused and full of unreality, and this confusion was reflected in the made-up world of their stories, in which adventures and wonders swirled around like the sparks from the campfire that devoured the insects, frightened off the wild beasts and provided heat for the storyteller and for those who listened. In those stories, animals could talk like humans, and men and women could fly like birds, or change their form just as caterpillars do when they turn into butterflies. The worldly and the other-worldly had no barriers between them, and, unlike in real life, time in these stories did not simply pass by; rather, it stopped, it went backwards, or it turned in on itself like a rattlesnake eating its own tail. All of the stories that were told back then were fairy tales, because life was still pure feeling and fantasy, without rhyme or reason. These tales and stories predated religions, and were also their foundations, providing the seeds to be nurtured by human imagination, by fear and by dreams of immortality; this process gave life to myths, theologies, philosophical systems and other wonderful architectures of the mind. Storytelling brought the tribe together and held the tribe together, because stories are designed to be told to other people; bound by the spell of shared sto-

ries, those "others" become us, and all become one. Stories pulled primitive man out of his solitude and turned him into a member of a collective body under the magnetic attraction of fiction, to share ancestors, gods and traditions, and to recognise his own history.

And so, side by side with real life, made up of sweat, hunger, routine and illness, came another life, made up of fantasy and words. This other life could be heard around the campfire and it stayed in the memory, like a wine that could be sipped from time to time to rekindle that euphoria which transported the human being out of the real world and into another, a world of illusion and endless adventures, a world where even the wildest dreams could come true, and where men and women lived life over and over and cheated death. The stories in which the ancients became absorbed held for them a freedom unknown in the sordid and soul-destroying routine of their everyday existence and gave them the illusion of immortality. That "other" life of stories was, in the elemental struggle for survival of prehistoric times, the only one that truly deserved to be called life; for what filled their days and nights was barely a simulacrum of life, no more than a form of slow death.

In this way, this other life, the one of fables, grew up parallel to real life, yet remained impalpable, spoken, freed of chronological constraints and without the conditioning and servitude of real life; a life of wonders in which human beings could fly, birds could speak, old people could become children and the brave could travel in time or penetrate the very heart of the trees and the stones and hear the secrets of the flames and of the stars. Making up and telling stories was a way to make life bigger and better, it was a way to exorcise sadness and, although it was no more than a brief pause from reality, it was a way to see the world,

not through the eyes of a wretched mortal, but through the eyes of a god. By sheer accident, human beings had discovered a palliative against adversity; but it would also prove to be an extremely dangerous weapon. In effect, fiction had appeared unassumingly as a way to combat the tedium of prehistoric man and his ancestral fears; but it would become a spur for his curiosity, a limitless stimulant for his imagination, a fuel for his wishes and desires, and the driving force of his dissatisfaction. Giving themselves over to the task of creating ever more audacious stories, human beings would make their feelings and desires ever richer and more subtle, continually rediscovering the extent of their freedom. Freedom, that constantly expanding space in which, by augmenting the illusions of the dream life of stories and tales, man would be capable of greater heroic deeds, of adventures that would deepen his knowledge and his control of nature. Fiction allowed men and women to extend infinitely those limits of the human condition which, unlike in the made-up worlds of their stories, were always inflexible in real life.

Tales gave to the listener a certain sense of security within the dangerous anarchy in which they lived. Tales gave them a sense of order, which, although filled with wonder, was no less real, because they believed in it. Reality could be seen to be ordered in an intelligible way thanks to fiction which gave shape to life and gave meaning to death; thus, men and women felt protected within a system that exorcised their fears, offered reward for their sacrifice, and relief from their suffering in the afterlife.

Did fiction make men and women happier? It made them more restless, less resigned to their fate, it gave them more freedom and made them bolder. But we cannot say with any certainty that it

made them any happier, except in those intervals of unreality in which, lulled by the voice of the storyteller, they lived the fiction as though it were real life. Later, when the spell was broken and they awoke from the dream, what sadness befell them; what frustration, what nostalgia they felt, those spellbound listeners, when they realised how dull the real was in comparison to the imagined.

With the arrival of writing, the art of storytelling underwent a radical shift. It ceased to be the collective act of creation that it had been since its birth; rather than a ceremony shared by a group, it now became an individual pastime and a private activity. From then on, stories reached their public through that, not passive, but most active of intermediaries: writing. These codified signs, discreetly but inevitably imposed on the narrated story a different course from the one marked by the oral tradition; signs that the writer had to use, employing all manner of devices to simulate, in the silence of reading, the voice—the intonations, the silences, the emphases—and also the facial expressions and the gestures of the storyteller.

Before the written word, stories poured forth into all areas of life. This is true to such an extent that, in those prehistoric times—in other words, in a time before writing—the most refined literary devices and disciplines had not yet established a clear dividing line between lived history and the invented life of fiction. This world of fables came to us through the oral tradition and the great epic poems, mythologies and theodicies that founded cultures and civilisations. In these, life and dream, history and fiction, reality and fable merge into one, like fantasies in the mind of a child that are always believed to be real. Reading imposed a more intellectual orientation on fiction. Until then, stories had first assailed the senses, the emotions, the feelings and the instincts of the listener, and only later their intelligence and reasoning. But writing brought rationality into the foreground in the understanding of stories with its demand on the reader to convert the linguistic sign back into images and ideas. In this way, "realism" was born, a mandate for verisimilitude, according to which the narrative text must adapt itself to the rules of reality. However, these rules rely on knowledge and experience, as well as on superstitions, spells, magic and the infinite tricks which conceal ignorance. As a result, and in spite of its realist pretensions, narrative literature continued to reflect, throughout its evolution, a world in which history and fable, experience and invention, reality and illusion irresistibly merge into one.

In the solitude of reading, narrative fiction revolutionised love, sometimes sublimating it and at other times impregnating it with rituals and sensuality. The invented life of literature played a decisive role in the humanising of physical love which little by little, thanks to the images and the fantasy of literature, became ceremony, theatre, adventure and creation, at the same time as celebration and pleasure of the senses. Eroticism, or the humanisation of physical love, would never have been born without the help of fiction.

With the unstoppable advance of knowledge in all spheres and its inevitable consequence, specialisation, knowledge would gradually become like an archipelago, or rather, perhaps, a jungle, in which each researcher, scientist and expert technician must clear their little space to become its lord and master. But the idea of sharing would be lost under this dissemination of specialist knowledge. In that universe of fragmented and partial knowledge, only fiction would retain undiluted until today its totalising vision of that life in which, as in Georges Bataille's definition of man, "Opposites merge into one."

Lima, February 2004

This essay was originally published in the magazine *Letras Libres* in July 2004

Translated into English for *The Storytellers* by Dr. Phil Morris, 2012

DENARRATIONS, UNBINDINGS

Gerardo Mosquera

Tracey Snelling
Rainy Night (based on *As One Listens to the Rain* by Octavio Paz)
2012
Wood, paint, faux water, lights, lcd screen, media player, speaker and transformer
Courtesy of the artist and Rena Bransten Gallery, San Francisco

In spite of its title, *The Storytellers* is less significant for what it narrates than for what it "denarrates." It was inspired by Mario Vargas Llosa's *The Storyteller*,[1] which sets in parallel the voices of a contemporary novelist (to a great extent the author himself) and a Machiguenga oral storyteller from the Amazonian jungle. The novel—in which the worlds of the two narrators confront and contaminate each other—is a reflection on the possibilities of literature. It might also be a metaphor about the "coexistence of times" in Latin America, with its dramatic social and cultural contrasts and asymmetries. Motivated by the conflicts of narration addressed by Vargas Llosa's novel, the exhibition presents artworks that use a narrative structure and simultaneously discuss, deconstruct or even subvert narrative conventions. While the artists included have very different poetics and backgrounds, and their works range from installations to videos to paintings, all of them share a will to narrate and to denarrate. These denarrations tell diverse stories by reinventing narration in unexpected ways, and questioning the internal mechanisms of narrative. As in Vargas Llosa's novel, the conventions established by literature are put into question. The works relate distinct tales—some humorous, as in Cristina Lucas' video; some disturbing, as in Tracy Snelling's installations—but their main story is storytelling. This is not necessarily a conscious, programmatic, or conceptualised process, but just a natural way for artists to deal with complex meaning in their works.

After the epistemological cut introduced by Pop, Minimalism, and Conceptualism, contemporary art became more presentational than representational. In a way, it turned into "a thing," not in the sense of a utilitarian object, but, as Marcel Duchamp used to call his own artworks, de-emphasizing art's traditional functions and aura. Minimalism introduced what Michael Fried called "objecthood," a "literalism" that made it impossible to separate art from a real, concrete object.[2] Aura was kept for legitimating and market purposes, but art became even more autonomous—a "new reality"—and more about itself: a rather self-referential and disenchanted activity. Representation's artifices were set under scrutiny, symbolisation lost currency, Frank Stella's "what-you-get-is-what-you-see" permeated the post-Minimal practices that have so crucially conditioned contemporary art, while ideas, language inquiries, attention to processes, and the creation of "situations" prevailed in art on a global scale.

Obviously, narration was also affected, although it was so well installed historically in literature, theatre, and art—and perhaps it remained so compelling—that it never disappeared. But representing "reality" and telling stories—two of art's main functions throughout its history—were displaced by the broader, very rich methodological, morphological, and hi-tech scope that art has acquired. Art, even more than "a thing," can be anything today: it no longer has to fulfil established roles. Paradoxically, the term "narrative," taken from post-Structuralist theory, is broadly used in art jargon nowadays. However, it refers more to certain meaning, value, and ideological frames than to actual narratives articulated in the artworks.

This contemporary refusal to tell stories in art also has to do with scepticism toward the very possibility of communicating experience through narration in our intricate times, when the gap between art, literature, and life, as well as between the "real" and the virtual, has critically in-

creased in an era of artificiality. Walter Benjamin announced the situation a long time ago in a 1936 text with an identical title as that of Vargas Llosa's novel:

> In every case the storyteller is a man who has counsel for his readers. But if today "having counsel" is beginning to have an old-fashioned ring, this is because the communicability of experience is decreasing. In consequence, we have no counsel either for ourselves or for others. After all, counsel is less an answer to a question than a proposal concerning the continuation of a story which is just unfolding. … The art of storytelling is reaching its end because the epic side of truth, wisdom, is dying out.[3]

For Benjamin, wisdom was "counsel woven into the fabric of real life."[4] In his view, the earliest symptom of the decline of storytelling was the rise of the novel at the beginning of modern times and separation from life: novelists isolating themselves, losing the direct contact and living communication with the audience that oral literature enjoyed.[5] This predicament between modern written narrative and communal oral storytelling is also tackled by Vargas Llosa's novel, where these two systems, their times, and worldviews engage in a tense dialogue. However, the novelist—although expressing enthusiasm for the days when storytelling could be "more than just fun, something of paramount importance, something that the very existence of a people depends on"[6]—does not assume Benjamin's scepticism, and communicates a more affirmative view. He stated it outright in his Nobel Prize speech in 2010:

> Thanks to literature … civilisation is now less cruel than when storytellers began to humanise life with their fables … Fiction is more than an entertainment, more than an intellectual exercise that sharpens one's sensibility and awakens a critical spirit. Literature is a false representation of life that nevertheless helps us to understand life better … It is an absolute necessity so that civilisation continues to exist.[7]

At the very emotional occasion of receiving the Nobel Prize, the writer changed nostalgia for the storytellers' old golden age—when, as opposed to what happens today, storytelling was vital for society, as expressed in his novel—for a very explicit assertion of the power of literature in the present time, following a poignant, humanistic endorsement.

The exhibition's title was borrowed from Vargas Llosa's novel, and its content was shaped by the reflections on narration in it, as well as by the resonances emanated from the double narrative exercise that constitutes the novel, with its different voices, cosmovisions, styles, and stories. The vexed assertion of the plausibility of narration in Vargas Llosa is confronted by Benjamin's pessimistic view on the subject in his text. The coincidence in titles is put in tension by the difference in content, lending the exhibition the potential to become a space both of assertions and negations framed by an intricate debate occurring within the exhibited artworks and in their interaction. They engage in a provocative, Bakhtinian dialogue between telling and un-telling, suggesting even more stories than the ones that they denarrate.

If, in general, contemporary art is not so inclined to "tell stories," the proliferation of video and its extraordinary impact on today's life has pushed in the opposite direction. Video's time and sequential components and its documentary-based possibilities have chiefly contributed to

Monika Bravo
Landscape of Belief
2012
Interactive time-based installation

revamp narration, even if only to a limited extent. By the same token, video and film have subverted narrative conventions more than any other art form. A good example is Cao Guimarães' and Pablo Lobato's film included in this exhibition. If this film still "narrates," there is a major tendency among many video artists around the world to contradict video's narrative power to have it explore other terrains or penetrating deeper into Conceptual, Minimal or Abstract poetics. William Kentridge and Nina Yuen work against this current: they are born "storytellers" to the point that they look "old-fashioned" in a misleading way. Their artistic force comes from their fascination with narrative and their desire to simultaneously alter it from the inside by telling stories differently: playing with old narrative schemes in challenging manners. They narrate by denarrating and by reinventing narrative.

The group YOUNG-HAE CHANG HEAVY INDUSTRIES narrates its witty stories and statements using sheer text in their time-based Internet work, which is also projected on gallery walls, as in this exhibition. This work could be considered a new kind of literature, since it depends on writing language. It is also a linear narrative, a sort of teleprompter. However, these artists activate some very simple visual features of the Flash programme they employ to denote meanings that modulate what is being narrated by the text. Their work evokes a productive, ambiguous zone where narrative, language, and visual image interact in denarrative ways.

No less important than video's impact on art has been the deconstruction of narration as a result of the critique of representation undertaken by post-Structuralism. It has stimulated new critical narrative experiments: every deconstruction is a self-deconstruction. Therefore, the deconstruction of representation and narrative in today's art has fostered new critical approaches to both that have, paradoxically, extended their practice. What Monika Bravo has written about *Landscape of Belief* could be applied to other pieces in the exhibition, as well as to the way in which some contemporary artists use text in their work: "I think of text as the potentiality of form; as the space in between, the vehicle of infinite probabilities, not so much as direct meaning but as abstraction and embodiment of the possibilities of the mind."[8] In this line, a crucial source for denarration has been narrative's polysemous character, a fertile soil for artistic re-

William Kentridge
Journey to the Moon
2003
Courtesy Goodman Gallery, Johannesburg

search, as we can see in Marilà Dardot's operations with literary texts. In other cases, denarration is literal: Valeska Soares creates facsimiles of existing books with blank pages, as if their narratives were kept away from their material vehicles, obliterating books' customary uses to change them into open spaces where readers, at the absence of something to read except titles, can project their own stories. More about "silent" books in this show later.

The exhibition *The Storytellers* articulates sharp examples of this somewhat against-the-grain orientation in contemporary art. It comes as no surprise that many of the artists included in the show are from Latin America. This is not only because the exhibition's idea and title were inspired by Peruvian Mario Vargas Llosa's novel, which reflects on the continent's conflicted social and cultural tissue. In this region, where literature is so powerful, we find a tendency among numerous artists to use narrative structures in their works, as well as symbolic elements. This might be in part a result of the confrontational role played by much art in the region, and its urgency to tell and discuss things in a context of dramatic inequalities and social problems. Critical art in Latin America is paradigmatic for its plausible drive of the political and the aesthetical, for its complexity, variety, and reach. Narrative and symbolic art practices are not exclusive to Latin America, but they are more frequent there, although they do not permeate all of the region's art, which is actually quite varied.

This show is about narration and literature, but it is also about books. Can they be separated today? As Benjamin pointed out, "what distinguishes the novel from the story (and from the epic in the narrower sense) is its essential dependence on the book."[9] This submission to the book as intermediary has broken away from oral literature's collective, immediate, live communication between narrator and audience to benefit distance, individual consumption, and text preservation. Even if every writer writes for somebody, targeting a real or ideal audience, as Jean-Paul Sartre insisted, at the end they all write for a book, for the creation of a book, for the framework that every book determines.

Several artists in the exhibition play with or deconstruct the book as an entity; material and in-

tellectual components are intertwined and function according to deeply instilled customary uses. These artists "debook": they deal—in revealing ways—with the book as an object and a vehicle, and with its conventions. They use books to build the artworks while putting them at stake. In *The Surge of the Sea*—an installation dated 1991–97 that in the end was not included in the show but merits a comment here—Cildo Meireles displays on the floor dozens of volumes (printed under his instructions) containing only photographs of water, which compose a highly poetic image of the sea. He has called this work a low-tech representation. Indeed, he uses the material configuration of the book as a "low-tech" object in a totally unexpected way to configure a visual imitation of the sea, while, in a suggesting twist, the word "water" is pronounced in many languages through loudspeakers. Each book remains open in a given page, its normal function denied: these are not books for reading or browsing, but constructivist elements put together to build a broader image, as if they were tiles.

Fabio Morais sculpts books in a manner reminiscent of how they look after having been attacked by insects. These volumes have therefore lost their faculty to communicate their content through reading; they have been mutated into abstract sculptures that put to the forefront the book's material aspect, or the ruins of it. Likewise, Mónica Bengoa's felt mural reproduces an angle of an open encyclopaedia just to show its visual aspect. It is again a publication that we cannot read, a paradoxical encyclopaedia that is unable to treasure and communicate knowledge since it has been reproduced only for its material shape, as the model for a formal, and handicrafted experiment.

Examination of the crosscurrents of objecthood, image, text, and representation in the book is particularly relevant in Milena Bonilla's handwritten *El Capital / Manuscrito Siniestro*, 2008. To create her work she copied a Colombian edition of Karl Marx's emblematic book with her left hand, making it quite unreadable. Her endurance piece is an overwhelming critique to the deification of Marxism as a political religion of the book. On the other hand, is a handwritten book a middle ground between the writer and the oral

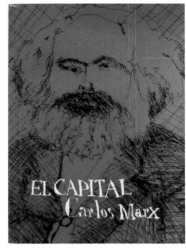

Milena Bonilla
El Capital / Manuscrito Siniestro
2008

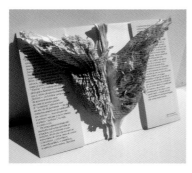

Fabio Morais
Migração
2006
Books sculpted as butterflies
Private collection, Bogota

Mónica Bengoa
Einige Beobachtungen über Wildblumen:
Bienen-Ragwurz (Ophrys apifera) und
Schachblume (Fritillaria meleagris) or
Some Considerations on Wild Flowers:
Bee Orchid (Ophrys Apifera) and Chess
Flower (Fritillaria Meleagris)
2011
Wool felt cut out by hand

storyteller? Among other things, her piece also contradicts the book as a means of communication based on and created by printing. This is also the case with Ryan Brown's book covers, painstakingly hand-painted by him to the point that these props look like "real" publications. The titles he painted were chosen by him to organise possible—and credible—libraries, each with a distinct character, which he shows in several shelves. His work is thus a painterly representation of books but also of readers, who are depicted by their personal libraries in an exercise in portraiture without faces. Brown's installation also suggests that the book demands the library: it is a collectible. Its design as an object implies the shelf and its accommodation to it. Related to this implication, and more crucial, is the book's instrumentality to store, preserve, fix, and enshrine knowledge.

The fact that so many artists in this exhibition focus on books is a symptom of how weighty the book—a stronghold of analogue communication—continues to be in our digital era. The book has been around for ages and is quite rooted in our customs, feelings, and imaginations. Contrary to what happened to the typewriter—an emblematic representation of the writer, as was the feather pen before it—which became obsolete and disappeared overnight, the book will prevail. Not that it will survive: it will just continue ahead, following its own path in a relaxed mood. A result of having unyielding uses, spaces and, crucially, bonds to subjectivities. Something similar happened to the handcrafted, "primitive" wooden pencil—which continues to be as useful as always—to painting after the emergence of photography, to theatre after cinema, and to cinema after television.

The book is so established that its condition has permeated language, and language has contributed to construct its representation and significance. The word "book" has expanded its meaning to refer both to the item and to its content. One says: "Mario Vargas Llosa is writing a new book," when he is actually writing a novel or an essay. Such displacement is natural, since the book—as a material artifact—in some ways determines the content that it delivers. No matter whether it is *De la grammatologie* or *Finnegan's Wake*, every text printed in a book

is a linear narrative in objective terms, one that has a beginning and an end, and which is closed on itself within the material, spiritual, and temporal field determined by the book. Written language requires a surface to be possible: stone, wood, papyrus, paper, screen… It links communication to a physical entity that excludes improvisation, change, response, and other immediate, performative acts intrinsic to oral literature and live communication—related to time, direct interaction, and a shared experience, not to an artifact and to disconnection between narrator and reader. The book conditions an individual use, quite distant from the storyteller's collective experience and even from radio or television, which are more gregarious and interactive (zapping, participation in programmes via telephone, etc.). Through the book, the contact between writer and reader takes place over space and time. Actually, every book—even the hottest bestseller—always comes from the past and preserves it, keeping a text that has been already written for it. Very importantly, as opposed to the oral storyteller's performance, books avoid contingency in benefit of controlled order. That is not to say—paraphrasing Marshall McLuhan's hyperbole—that the book is the message. However, language has, in fact, been modulated by its material frames and conditioned to create conclusive pieces of speech forever associated to their enclosures (the Rosetta Stone, Vargas Llosa's pocket book, *The Storytellers*' catalogue…), which circumscribe both space and time. Books might open minds, but they force their content to be finished, closed, detained in time. In this sense, every book is conservative: a stop sign.

As a result, all books imply a certain exercise in transcendence. Extreme cases are the so-called religions of the book (Judaism, Christianity and Islam), based on holy books believed to be receptacles of the word of God, the prophets and the saints, but which turn into its personification. Since Hammurabi's days, law has also been kept and made sacred in iconic "books" that rule over social life: from Moses' Tables of the Law to the Constitution. Beyond all these sacred texts, in every book there is always a content that has been permanently treasured—as a jewel, as something well achieved,

and therefore definitive. The book fixes. It materialises the discourses' authority. Luis Britto has written a humorous, fantastic short story in which books were made out of a special paper that rotted after a certain time.[10] Although such a paper would have been a good solution for the overpopulation of books that we experience, it will forever stay in the realm of fiction, since books are signed by the anxiety for transcendence and preservation—hence, the ironic comment in Britto's short story. More significantly, it is as if the content in a book permeates the artifact to the point that the object becomes the text itself. In the Haein Temple, in South Korea, believers parade with wooden printing blocks of the Tripitaka Koreana (a collection of matrixes with Buddha's teachings) on their heads during a yearly ceremony that pays homage both to the blocks and their content, while ritually depositing Buddha's knowledge and spiritual energy straight on the believers' heads. In a simpler rite, people swear with their hands placed on the Bible, the Quran or the modern Constitutions. In these books, content and medium are forged in a single unit, acquiring a ritual character. To a lesser degree, something similar happens with every book.

The book format has conditioned the mode in which literature and knowledge were conceived, and the manner in which they circulated and were kept over centuries. This model has been challenged for the first time by the Internet, with its hypertexts, its wikis, its capacity to facilitate interactions at a distance and real-time communication. These new possibilities are transforming the previously established "closed" and "detained" approach to writing, reading, studying, and communicating. Nevertheless, as I said before, the book will continue, paradoxically, thanks to its objective quality. This quality has defied the epistemological cut introduced by the Internet, a transformation that goes back to the storyteller's past role of live interaction, as it overcomes distance and hampers centralised controls. The book's challenge to digital communication has not only to do with its persistence, but with the creation—and proliferation—of the tablet following the book's model. So, the Internet ended up by imitating the book. This is not only because the book format is more comfortable to read and is linked to long-established reading habits. Also, the book's capacity to integrate text and medium in one objective entity bestows on it a fetishistic character. To the extreme that, through the book, believers can read, learn, and experience the word of God; not least, they can also objectify, represent, adore, and cherish it. In the same direction, we can have the world's knowledge or the best poetry living with us at home, sleeping with us as lovers in bed, and by our bedsides.

People develop subjective, intimate relationships with books by virtue of their existence as discrete objects—each one with its own size, shape, weight, colour, texture, smell, design—that we can see, mark, touch, and caress. Sen-

Ryan Brown
Collection # 4 (Either/Or)
2010
Detail
Acrylic, graphite, watercolour,
ink and glitter on paper on wood
Courtesy of the Zabludowicz Collection,
London

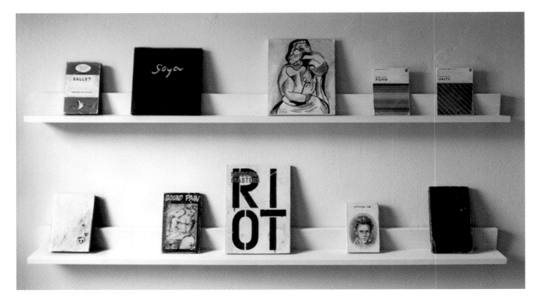

Ryan Brown
Collection # 4 (Either/Or)
2010
Acrylic, graphite, watercolour, ink and
glitter on paper on wood
Courtesy of the Zabludowicz Collection,
London

suality and even eroticism are associated with books. When we read the book is in our hands, sometimes set on our lap. We cannot separate the act of receiving the book's intellectual content from the physical, even intimate, contact: we embrace the book and its content together. Our relation with books corresponds to the particular integration of the "immaterial" language, narrative, knowledge, and discourse that they hold, and their key materiality as a medium, together with the individual, personal way in which it works, and its impact on our subjectivity.

The artists in this exhibition narrate to denarrate and create books to debook, to critically unbind. This tells volumes (notice the expression: one tells "volumes," not words, stories or statements) about how these two deconstructive activities are intertwined as a result of narration's dependence on the book and their mutual implications. To denarrate implies a self-critique of narration in the making of it, and to debook is to critically inquire into the book itself and the way in which it has defined narrative, literature, communication, and other related things. It also means using the book in other, alien ways, deconstructing its established functions, their implications, and the habits associated to them; stretching the book to fulfil imaginative, unforeseen roles. To that end, books are reinvented both physically and conceptually in the artworks. By deconstructing or critically unbinding them, the artists advance a step further on the discussions undertaken by Vargas Llosa's novel (which could be regarded also as a denarration) and Benjamin's essay. As visual artists, it is natural that they focus not only on analyzing narration, but also on the objectual rendering of narrative into the book, an artifact that one sees

as much as one reads. The difference between seeing a book and reading it clearly denotes the book's personality as a material thing. By doing so, the artists have provocatively shed light on the book as a thing in itself and the way in which this object has transformed the ancient art of storytelling. They thus emphasize a crucial element—the book as a material instrument—that, even if mentioned, was not specifically examined in the discussion about narration that has inspired this show. Deconstructing narratives and deconstructing books are two not so frequent and yet important pursuits in contemporary art. By presenting some salient examples, the exhibition brings attention to the issues they unfold, stimulating discussion on the subject and its abundant and fascinating reverberations, while aiming to explore the relations between contemporary art and literature.

[1] It is interesting to note that its original title in Spanish, *El hablador*, is more suggestive than its English version. It does not translate exactly as "the storyteller," but rather as someone who talks too much (and indiscreetly), therefore connoting a more nuanced reference to narration and storytelling.

[2] Michael Fried, *Art and Objecthood. Essays and Reviews* (Chicago: University of Chicago Press, 1998).

[3] Walter Benjamin, "The Storyteller," in idem, *Illuminations* (New York: Schocken Books, 1969), p. 364.

[4] Ibid.

[5] Ibid.

[6] Mario Vargas Llosa, *El hablador* (Barcelona: Seix Barral Biblioteca Breve, 1987), p. 92. "Son una prueba palpable de que contar historias puede ser algo más que una mera diversión … Algo primordial, algo de lo que depende la existencia misma de un pueblo."

[7] Mario Vargas Llosa, "In Praise of Reading and Fiction," Nobel lecture, Stockholm, December 7, 2010, http://www.nobelprize.org/nobel_prizes/literature/laureates/2010/vargas_llosa-lecture_en.html.

[8] Monika Bravo artist statement about *Landscape of Belief*. Published on her website www.monikabravo.com.

[9] Benjamin, "The Storyteller," p. 364.

[10] Luis Britto, "Putre," in idem, *Rajatabla* (Caracas: Monte Ávila, 2004), pp. 99–100.

FROM MARS
TO ABBOTABAD

or How Barthes, Baudrillard, Obama, Superman, and Osama Got Seated Around the Same Table

Paco Barragán

Humankind has always been in search of stories, good stories. The need to understand civilisation and its values helps us to accommodate reality and apprehend the world around us. How do we separate *fact* from *fiction* in our hypermediatised society? Our memories and our histories are the product of the stories we tell ourselves. A myth was an account of a remote past, and as such regarded as historical or even obsolete. But myth has worked itself into the modern discourses of politics and entertainment in the form of "storytelling." Cinema, television, and the ubiquitous social media have become its favourite playground.

In his book *Empire of Illusion. The End of Literacy and the Triumph of Spectacle*, American writer Chris Hedges explores the realms of illusion and fantasy in contemporary American culture. Hedges starts his book about celebrity culture with a thorough description of the world of professional wrestling with its complicated fictional back stories that include betrayals, infidelities, abuse, and outrageous behaviour among wrestlers.

"HBK!!! HBK!!! HBK!!!" chants the crowd. The Heart Break Kid saw his savings and retirement funds evaporate. The story tonight is of financial ruin, abuse and desperation. For The Heart Break Kid, as for most of these wrestlers, writes Hedges, "[i]t is only in the illusion of the ring that he is able to rise above the small stations in life and engage in a heroic battle to fight back."[1] This is the appeal of professional wrestling.

Roland Barthes also argued that "catch" wrestling was a matter of "justice." I suppose Hedges did not read Barthes' book *Mythologies* — he does not quote him throughout his chronicle of unfettered American capitalism nor mention him in the index — but already back in the mid-1950s Barthes started his book of essays with an interesting article titled "Catchworld." Played out in second-rate clubs, Barthes argued,[2] the public adored the spectacular character of the fight and did not care whether the fight was fake or not — what really mattered was not what one believed, but what one saw. It is not about success, but about a series of short, intense and passionate images and the catcher's task is to carry out those actions that are expected from him; just like in the theatre of ancient Greece where intrigue, language and accessories such as masks contributed to an exaggerated staging of destiny. The audience demands passion or, better said, a representation of passion, as authenticity is not at play.

So, we have here a shift from content to form: suffering is presented in a convincing manner, all the actions that cause pain are spectacular, but it is once again about the perfect representation of these images. Catch wrestling possesses a similar power of metamorphosis like theatre and religion. Because catch wrestling — as Barthes reminds us once more — is basically about a purely moral concept: justice is one, if not the biggest, of our myths.

In America, wrestling has turned into a sort of mythological fight between Good and Evil — think of The Russian Bear, The Iron Sheik, and Colonel Mustafa; it is also a fight between Fortune and Failure: the anxiety that we will die and never be recognised or acclaimed, that we will never be wealthy, and that we are not among the chosen but remain part of the vast, anonymous masses. As with classical myths, the success with wrestling and most entertainment that permeates our contemporary culture lies not in fooling us that these stories are real. Rather, it suc-

ceeds because we ask to be fooled. As Hedges says, "We happily pay for the chance to suspend reality. It is the yearning that life conform to a recognisable pattern and provide ultimate fulfilment before death."[3]

As often happens in celebrity culture, politics, and also in art, the line between public and fictional personas becomes blurred.

Mexican artist Carlos Amorales has also been attracted by wrestling. Some of his "interventions" were produced within the Mexican wrestling milieu, which helped him not only to analyze the sport itself, but also to delve into its myths and extrapolate on its social, political, and economic ramifications. The different characters that hide behind the so-called "Amorales" mask act out, comment, and participate in a documentary in which fiction and reality are exchanged, as we can witness for example in his *Arena Dos de Mayo* (Second of May Arena), 1997.

Ferdinand de Saussure dismissed the notion that language simply reflects reality, suggesting instead that language operates within its own system that is inextricably linked to social, political, cultural, religious, and economic ideas. Barthes developed this notion further by stating that meanings can develop beyond their linguistic properties and take on the status of myth. According to him, myths appear, change and die, and it is because of their historicity that myths become unstable. It is obvious that media are the major generators of myths. Cinema, television, radio, and social media nurture some myths and not others. But myths like identities and morality also shift with the wind. And as subjects or citizens we need to constantly define what it means to belong, to recognise our place in society and to conduct our lives.

The Art of Telling a Story

The basis of storytelling is deeply rooted in myths and its mythological tradition. In the 1980s companies moved from selling products to selling brands. And back then—as Christian Salmon keenly points out in his book *Storytelling. Bewitching the Modern Mind*[4]—it was Reagan who conceived a counter-reality that moved the attention away from essential problems, creating a world of myths and symbols in order to make citizens feel at ease with themselves and with their country. And this is how storytelling or "the art of telling a story" made its way to the top.

Since then, argues Salmon, capitalism has turned into a permanent electoral campaign in which religion, economics, and politics interact, commanded by the art of storytelling as a system to impose ideas, generate jobs and control behaviours. Actually, the Obama campaign was one of the best stories ever told! This narrative imperialism constructs stories that are being interiorised by the audience, even if reality has been totally dismissed.

Before, vision guaranteed faith. Now it is inadequate, you also need to create a story. The manipulation of information, as later turned out, played a major role in the American invasion of Iraq in 2003. Based on a series of fake stories they invented themselves, the army of *embedded* journalists hired by the White House "created its own reality" using all the techniques of the "fictionalisation of the real." No one wonders why no weapons of mass destruction have been found, after all, UN officials were chasing a story, a plot… Also Baudrillard already warned us that "the Gulf War did not take place"[5] (he refers to Operation Desert Storm between August 2, 1990 and February 28,

1991 as a response to Iraq's invasion and annexation of Kuwait), arguing that post-Modern societies had entered an age of "simulation," and more particularly an age of "third-order simulation": reality and representation are disconnected and instead we have "hyperreality."[6] The war has also earned the nickname "Video Game War" after the daily broadcast images on board the American bombers during the military operations. Let's consider in more detail how his theory of simulation casts doubt on the "reality" of the Gulf War. For most people the war consisted of screened images shown on CNN and other Western media. No traditional war with big combats and casualties, much more like a video game simulating real war in a media-saturated spectacle. What Baudrillard called a "non-event," an event that does not take place. What happened later to the weapons of mass destruction that Iraq was supposed to possess? They did not exist. Obviously, we have to discriminate here between degrees of authenticity.

But authenticity, fact, truth, reality, and representation are subject to a rampant relativism these days. After all, storytelling pursues a continuous re-writing of history in order to adjust the myths of the past to a more convenient present. And along with it came an unprecedented interest in the "conspiracy theory" as narrative genre: complex plots put in motion by powerful hidden forces.

Conspiracy Theory 1:
The Invasion from Mars

As most forms of communication—from myths to propaganda, to storytelling—become unavoidably imbued with ideology and hegemony, I suggest moving back to the 1930s for our first case study:[7]

> ANNOUNCER: I'm speaking from the roof of Broadcasting Building, New York City. The bells you hear are ringing to warn the people to evacuate the city as the Martians approach. … No more defences. Our army wiped out… artillery, air force, everything wiped out. This may be the last broadcast… Now the smoke's spreading faster. It's reached Time Square. People trying to run away from it, but it's no use. They're falling like flies. Now the smoke's crossing Sixth

> Avenue… Fifth Avenue… 100 yards away… it's 50 feet.
> SIGNAL TO THE ANNOUNCER IS LOST.[8]

This was the most frightening passage of a radio transmission on the night of October 30, 1938, between 8 and 9 pm, the day before Halloween, on CBS. The broadcast was an adaptation of H. G. Wells' novel, *War of the Worlds*. It starred Orson Welles and a small cast of young actors. The play involved the invasion of several American towns and cities by evil Martians riding around in giant tripod machines with hands that emitted destructive heat-rays. "Long before the broadcast had ended, people all over the United States were praying, crying, fleeing frantically to escape death from the Martians… At least six million people heard the broadcast. At least a million of them were frightened or disturbed," wrote Hadley Cantril.[9]

Why did so many people have cause to panic when they heard this play on the radio?

Conspiracy Theory 2:
The September 11 Attacks

On September 11, 2001 nineteen terrorists from the Islamist militant group al-Qaeda hijacked four passenger jets. The hijackers intentionally piloted two of those planes, American Airlines Flight 11 and United Airlines Flight 175, into the Twin Towers of the World Trade Center complex in New York City. At 8:46 am, five hijackers crashed American Airlines Flight 11 into the World Trade Center's North Tower (1 WTC), and at 9:03 am, another five hijackers crashed United Airlines Flight 175 into the South Tower (2 WTC). Both towers collapsed within two hours.

Suspicion quickly fell on al-Qaeda, and in 2004, the group's leader Osama bin Laden, who had initially denied involvement, claimed responsibility for the attacks. Al-Qaeda and bin Laden cited US support of Israel, the presence of US troops in Saudi Arabia, and sanctions against Iraq as motives for the attacks. The United States responded to the attacks by launching the doctrine "War on Terror" and invading Afghanistan to depose the Taliban, which had harboured al-Qaeda.

Unlike the Gulf War, 9/11 did take place and was—according to Baudrillard—"[t]he absolute event: the whole play of history and power is disrupted by this event."[10]

Following his line of thought we could state that, although the destruction of the World Trade Center was a real event, its "symbolic collapse" was more significant and came before its "physical collapse." According to him, "media are part of the event, they are part of the terror."[11]

Many artists have dealt with the 9/11 event. Now, the live broadcast over the Internet of the work *2001* by Wolfgang Staehle constitutes an unexpected—and even unintended—hallmark within this *Baudrillardian* context as it exemplifies as no other the shift from non-event to absolute event. A recording of the top part of the Empire State Building, *2001* began on September 6, 2011 and included synchronised webcam projections from three different locations: Comburg, a monastery in Hall, Germany; the television tower in the city centre of Berlin; and a view of lower Manhattan from across the East River. The broadcasted images changed every four seconds. Staehle clarified that his work was "against spectacle" and motivated by the philosophy of "what happens when nothing happens."[12]

Conspiracy Theory 3:
The Betrayal of Superman

"Why don't you move to France, coward?" was written on the front page of the *New York Post* on April 29, 2011. A couple of days before Superman, the all American hero, had entered the United Nations and handed in his passport. America was not representing anymore "truth, justice, and the American way." Superman was angry and annoyed. What had happened? Let's hear it from Superman himself:

"I follow the news," like I said. "And I saw the reports of the Iranian people demonstrating. There'd been violence the week before. Ahmadinejad's regime had overreacted. People had been killed. Some of the demonstration organizers had been disappearing. I stayed in Azadi Square for twenty-four hours. I didn't move. I didn't speak. I just stayed there. In that time, the protestors' ranks grew from 120,000 people to well over one million."[13]

Superman has spent much of his time as a superhero fighting alien invaders, time-travelling despots, rogues, and also apocalyptic threats by fearful communist enemies that threatened the "American way." Now Muslims are the new communists, especially since the al-Qaeda attacks on New York.

Reverend Mike Huckabee, one of the Republican contenders for the 2012 elections, said on Fox News: "I know it's just a comic, but it's shocking that Superman, that has always been an American icon, now says he doesn't want to be an American citizen any longer."

But was Superman American? Although he lived in Smallville, Kansas, America's so-called "heartland," he came all the way from planet Krypton. And secondly, his was a tremendously WASP-articulated discourse: he never saved Afro-Americans or other minorities, and thereby failed in representing the pursuit of race equality. Barkley L. Hendricks *Icon for My Man Superman (Superman Never Saved Any Black People—Bobby Seale)*, 1969, of which Trevor Schoonmaker says that "these images were visually and conceptually loaded and thus potentially threatening to many in mainstream society,"[14] and Fahamu Pecou *Nunna My Heros. After Barkley Hendricks' Icon for My Man Superman 1969*, 2011, in which the artists portrays himself as an Afro-American Superman, act out this disenchantment with the all American hero.

Conspiracy Theory 4:
The Assassination of Osama bin Laden

Bin Laden's death announced on the Sunday May 1st, 2012 nightly news launched the masses onto the streets and the "event" was greeted with animation and patriotic songs. President Obama addressed the American nation, announcing the death of Osama bin Laden. This speech was retransmitted worldwide by the major television broadcasting companies.[15] In his revealing speech, Obama clearly expresses the philosophy of the United States stating:

America can do whatever we set our mind to. That's the *story of our history*. Whether it's the pursuit of prosperity for our people or the struggle for quality for our citizens, our commitment to stand up for our values abroad and our sac-

rifices to *make the world a safer place*. Let us remember we can do these things not because of wealth or power, but because of who we are: one nation under God in the visible with *liberty and justice for all*. Thank you. May God bless You and may God bless the United States of America.[16]

Joe Klein wrote, in his *Time* article titled "Osama 1, Obama 0," "this profoundly American President ran an exquisite operation to find and kill one of the great villains of history."[17]

Laden's corpse—the US Government's official version claimed—has been consigned to the bottom of the sea in a way that would not offend Muslims. Until today nobody except a few Navy Seals has seen the corpse, only old photographs of bin Laden and many fake ones (some of them taken from Martin Luther King's death!), and even the White House Situation Room with Biden, Obama's and Hillary Clinton's view to a kill. As of today, Osama bin Laden's death photo has yet to be released. But the whole world could watch a 3D animation of the Navy Seals attack and killing of Osama rendered by Taiwan's Next Media Animation.[18]

This animation reminds me of Langslands & Bell's multi-channel video installation titled *The House of Osama bin Laden*, 2003, an interactive 3D simulation of the house in which the al-Qaeda leader lived in Jalalabad. As in a video game, the spectator can enter the house formerly occupied by Osama and move around and explore its surroundings with a joystick. Another strange example includes the portraits painted by Iranian Maryam Najd (Teheran, 1965), who lives and works in Brussels and Berlin. The ironic *Self-Portraits* are an ongoing series in which Najd selects individuals that are icons, like Obama and Osama. The works were exhibited together side by side in the show *The End of History… and the Return of History Painting* at the Museum voor Moderne Kunst in Arnhem (MMKA) before and after the killing happened.

Reality Is No Longer Relevant, Only a Good Story…

Now let's return to Barthes. The distinction between language and myth can be articulated in terms of "denotation" and "connotation," says Dan Laughey.[19] "Denotation" would be the mere neuter definition of the sign, and "connotation" implies wider social, cultural and political meanings (myths) attached to a sign.

So, how does Barthes' semiotic theory of myth apply to our conspiracy cases? We have several mass media generated myths that *denote* first a play broadcasted nationally throughout the United States; secondly a world-wide live television broadcast of al-Qaeda's attack of the Twin Towers; thirdly, a comic which depicts the adventures of Superman; and lastly, a 3D animation of the assassination of Osama bin Laden transmitted on television news world-wide and still accessible via YouTube. For Baudrillard all would be labelled as "non-events," except for 9/11, the "absolute event."

Now, if we want to interpret what these cases *connote* we need to recall Barthes' most famous example of myth-making: the front cover of the French magazine *Paris-Match* which depicted a black boy in a military outfit looking upwards and saluting the French flag.

On the level of myth Barthes suggests that the image signifies "that France is a great Empire, that all her sons, without any colour discrimination, faithfully serve under her flag."[20] The image of the proud black soldier connotes a myth that France is a multicultural land of opportunity far from an oppressive coloniser of foreign peoples. Now this image can be applied to Barack Obama: a proud Afro-American citizen that embodies the true nature of the "American Dream" and reinforces not only the myth of America as a land of opportunities, but also its commitment to prosperity, liberty and justice for all.

A petty detail is that Obama, like Superman, has been accused by Republicans, and Donald Trump in particular, of being "alien" and was forced to show his birth certificate. On top of that, Superman's performance at Azadi Square did not go unnoticed by the Iranian authorities: it jumped from the comic pages into everyday life causing a real diplomatic conflict between Iran and the USA.

The invasion from Mars, the attacks on the Twin Towers and the assassination of Osama bin Laden all respond to the same ideology: a biased, rigid representation of a "foreign" ene-

my which embodies destruction, violence and death. Hollywood science fiction and action movies were extremely reactionary: evil was a matter of communists or Martians, and since recently Muslims. The enemy is morally simplified and the "good war" does not allow any room for dissent or critical thinking.[21] The depersonalisation and de-humanisation of the invaders are applied to the new enemy, which is represented by the West as primitive, aberrant, fanatic, and inferior.

Stretching our imagination, this sequence of cases takes on connotations of one big Hollywoodian conspiracy theory: the Martians invade earth and attack the Twin Towers while Superman betrays mankind and kills Osama bin Laden.

Within this Empire of Illusion and the Triumph of Storytelling, the information system made up of "information packages" sold by news conglomerates like CNN, Fox News, Time Warner or Walt Disney favour an anecdotal version of events, a black and white representation of actuality that dismisses the frontier between reality and fiction. As such, conspiracy theories enjoy a certain popularity and adjust as a kind of counter-narrative perfectly to this kind of "consent packaging." Bill Clinton too offers a little known understanding of politics in his *Autobiography*: "politics are no longer about resolving economical, political or military problems, they should enable people to make better (hi)stories."[22] And this is one of the main reasons why social media like Facebook, You Tube, and Twitter have so much success: they allow us to tell our best possible story.

Be it wrestling, celebrity culture or war; a nation, a president or an ordinary citizen; they all share in common the need for a good story because stories allow us to alter our reality in a convenient manner, and by doing so we can finally satisfy our needs.

The question now would be: do Americans need Superman again now that Obama has killed Osama? The young crowd outside the White House on Pennsylvania Avenue kept chanting "U-S-A! U-S-A! U-S-A!" on the occasion of the announcement of the death of Osama bin Laden. It seems likely that Obama's re-election has been secured.

Capitalism constructs stories that are being interiorised by the audience, and as happened with Orson Welles and the Martians, the citizen has to discern fact from fiction. But, are we as citizens educated sufficiently to exhibit critical ability and make the adequate checks?

The Greek needed to *believe* in their gods. Modernity and mass media society showed us that "credibility" and "truth" are the mere result of what we *see* and what we *hear*; but now "storytelling" convinces us once again that what only really counts is what you *want to believe*!

[1] Chris Hedges, *Empire of Illusion. The End of Literacy and the Triumph of Spectacle* (New York: Nation Books, 2009), p. 5.

[2] Roland Barthes, *Mythologieen* (Utrecht: Uitgeverij IJzer, 2002), pp. 13–23. French edition *Mythologies* (Paris: Editions du Seuil, 1957). English edition *Mythologies* (London: Paladin, 1972).

[3] Hedges, *Empire of Illusion*, p. 6.

[4] Christian Salmon, *Storytelling. La máquina de fabricar mentiras y formatear mentes* (Barcelona: Ediciones Península, 2008). English edition *Storytelling. Bewitching the Modern Mind* (London: Verso, 2010).

[5] See Jean Baudrillard, *The Gulf War Did Not Take Place* (Sydney: Power Publications, 1995).

[6] Jean Baudrillard, *Simulacra and Simulation* (Ann Arbor, MI: University of Michigan, 1994).

[7] I am benefiting here from Dan Laughey's analysis and research, which on its turn quotes Hadley Cantril's investigation of radio's effects on human behaviour. See Dan Laughey, *Key Themes in Media Theory* (Maidenhead, Berkshire: Open University Press, 2007), pp. 16–19.

[8] Hadley Cantril, Hazel Gaudet and Herta Herzog, *The Invasion from Mars. A Study in the Psychology of Panic with the Complete Script of the Famous Orson Welles Broadcast* (Princeton, NJ: Princeton University Press, 1947), pp. 30–31.

[9] Ibid., p. 47.

[10] Jean Baudrillard, *The Spirit of Terrorism, and Requiem for the Twin Towers* (London: Verso, 2002), p. 4.

[11] Ibid., p. 31.

[12] Interviewed by Karen Rosenberg for *New York Magazine* http://nymag.com/nymetro/news/people/columns/intelligencer/9796 (accessed on May 28, 2012)

[13] Action Comics no. 900, *The Incident*, written by David S. Goyer and drawn by Miguel Sepúlveda, 2011, unpaged.

[14] Trevor Schoonmaker, "Barkley L. Hendricks: Reverberations," in Selene Wendt, ed., *Fresh Paint* (Milan: Charta, 2012), p. 98.

[15] See http://www.youtube.com/watch?v=B1P5uffnF_A (accessed on May 28, 2012).

[16] Ibid. (*Italics are mine*).

[17] http://www.time.com/time/magazine/article/0,9171,2069580,00.html (accessed on May 28, 2012).

[18] See http://www.youtube.com/watch?feature=player_embedded&v=KiUZGfYphxY (accessed on May 28, 2012).

[19] Laughey, *Key Themes in Media Theory*, pp. 55–9.

[20] Barthes, *Mythologieen*, pp. 211–31.

[21] See Susan Sontag's essay "The Imagination of Disaster," in idem, *Against Interpretation and Other Essays* (New York: Delta Books, 1966).

[22] Quoted by Salmon, *Storytelling*.

A CONVERSATION

Marilá Dardot and Cao Guimarães

My earliest memory of Cao is of a tall guy, a bit scruffy and very charming, who would always show up wearing slippers at our philosophy class in the Federal University of Minas Gerais in Belo Horizonte. He was a philosophy major, but I was just attending the course out of curiosity, as I was majoring in communications. That must have been sometime in 1995. He already was an artist; I did not yet know that I would become one.

We became friends then, I don't remember how—through mutual friends, or at some party, or during the long nights we'd spend talking in Belo Horizonte bars.

Since the late 1980s, Cao has been producing his artwork using photography, film, books, and installations. He's well travelled and has shown his work at the Tate Modern, the Guggenheim, Gasworks, and the Frankfurter Kunstverein. His films have been shown at major festivals: Sundance, Rotterdam, Tampere, Cannes.

My own art production began a decade later, at the end of the 1990s, and went back and forth among installations, videos, books, and objects. I've shown my work in several venues in Brazil, including the Museu de Arte Moderna in São Paulo, and the Museu de Arte Moderna Aloísio Magalhães in Recife. In 2006, I participated in the twenty-seventh São Paulo Biennial, and the next year I took part in the exhibition *Luz ao Sul*, the São Paulo-Valencia Biennial in Spain.

I began this conversation thinking about fiction, something my work and Guimarães' have in common, but in the course of the exchange we found many more similarities between our processes: how we think about art, how we think about the Other… Time, chance, death, and dislocation are a few of the interests we share.

Marilá Dardot Here I am, trying to figure out how to begin this conversation, which is hard because I know it's going to be published—otherwise it would be smoother. It occurs to me that it would be easier to talk about life than about art. To tell you the truth, I'm not too interested in art per se. Art only works when it manages to throw me around, far or near, forward or backward, sometimes a bit sideways: when I look at myself and I look at the other one in the mirror; when perception wanders along strange roads and overflows, when times become muddled and anxiety disappears. What matters then is not art, but the roads that lead to it and the places where art, in turn, leads us. In the end, or rather, in the beginning, I find that creating art is only a way to understand all of that, and to try to change its configuration a bit: the configuration of time, of the real, of love, and of solitude. And like you yourself said, everything begins by accident. Some will call that beginning a creative process, as if art were the goal. I'd rather call it desire. Or, like you, necessity.

I thus begin our conversation with a question about *Histórias do Não Ver* (Stories of Not-Seeing). Rereading your book—which was delightful and transported me elsewhere—I stumbled upon the word *estória* (story). I remembered my childhood, and my awareness that in Portuguese we had two words—*estória* (story) and *História* (history), the latter with all the power that the capital H signalled—and that they were opposites. *Estória* was fiction, an invention, what my father would tell me at bedtime. "That's a tall tale," we'd say about nonsense and idle chatter. *História* was what we learned in school; it was the truth and preferable to the word *estória*. I don't remember ex-

actly when I learned that one should not write *estória*, but I do remember that I reflected a lot about the matter. I stopped using the word *estória*, and everything became *história* (with an uppercase or lowercase H)—or, even better, everything became fiction.

In your book, both words are there: *Histórias* is in the title and *estória* too*,* as in when you heard "about the wedding traditions in particular regions of Muslim countries." Then I was confused. Did I dream that I was not supposed to write *estória*? When did I realise the absolute impossibility of distinguishing between the two terms?

I consulted the *Dicionário Aurélio*: I found the entry for *estória*, which read: "*Feminine noun*. See also: história." It turns out that the recommended spelling for the word is *história*, and that the term applies both to the field of history and to a fictional narrative or popular story. Doing a bit more research I discovered that it was a certain João Ribeiro who proposed the adoption of the term *estória* in 1919 to designate popular narratives and traditional stories for scholarly study in the field of folkloric studies. The distinction was adopted but went beyond the limits of folklore, especially after João Guimarães Rosa published his book *Primeiras Estórias* in 1962. And so both of us grew up with that dichotomy, which attempted to distinguish "reality" from "fiction," as if that were possible. I was very relieved when I saw the possibility denied by *Dicionário Aurélio* and by our language, which, in contrast to English, does not distinguish between *story* and *history*.

But, to go back to your stories, I notice that you translated your book title as *Stories of Not-Seeing*. That's a good topic for the beginning of our conversation.

Cao Guimarães *Istória da carochinha* (fairy tale). *Istória pra boi dormir* (tall tale). *Istória do Brasil* (the history of Brazil). The "Master of Masters" (the main character in my film *The End of the Endless* of 2001) told me we should write the way we speak. And so we should drop the H and write *istória* instead of *história*, the way it's pronounced. What you point out is quite interesting because it shows how a language can sometimes become bureaucratic, ignoring actual speech, the vernacular. In other words, the correct, erudite form of a language is often a piece of fiction. The actual body of language is like a gigantic amoeba that is constantly changing. It can never be apprehended in its totality. But, since language is one of the components that define a nation, a group of people, customs, and habits, and since human beings need these distinctions, we started to create limits and moorings for that body. Language is like mercury. It cannot be harnessed into a single form. The same goes for reality, and by extension, for history. There is no such thing as a single reality or an objective history, whether from a single viewpoint or infinite ones.

I am not very interested in limits that generate a single form. On the contrary, I'm more interested in the movement and/or processes that the body of the large amoeba undergoes. Art, as a language, and in contrast to what we want from languages, cannot have a final state. Art connects with universals and not simply the particularity of a certain people or culture.

My book *Stories of Not-Seeing* consists of experiences told through images and words. Experiences and realities prompted by a device—to be "kidnapped" by other people, blindfolded, and taken to places where I then registered my sensorial impressions with "blind photographs"

and written narratives. Even though I was the one who began the process, the detonating agent, that is, the one who "cast the dice and left it to chance" and who went through the experience of being kidnapped, this process is shared—with the kidnapper and the reader of the book.

There's an interaction between the agents of the process and those undergoing it, an exchange of roles and values. The artist is no longer the only creative agent. The "kidnapper," inasmuch as he creates a reality for the artist to experience, is also a creative agent. The reader of the book, the so-called spectator, becomes active in unveiling the realities that hide behind those images and texts, and mainly in establishing the relationship between them.

This type of participation also happens in a significant way in other pieces I've produced, such as the installation-film *Rua de mão dupla* (Two-Way Street), in which I ask people to switch homes. Both in *Stories of Not-Seeing* and in *Two-Way Street* I have a desire to share an experience, a reality that can be an action, an environment, or even a film or a book.

I see the same in your work when you prepare a sharing environment such as a library (which you call the *Library of Babel*), when you invite others to participate in "the process of building a dialogue" in your piece *Between Us*, or even in the reading of a book like Julio Cortázar's *Rayuela* (*Hopscotch*) in your installation of the same name.

I think about two issues that we both engage: what is the role of chance in your work and in your life in general? And what about the role of the "Other"?

MD Perhaps my entire life has been built around a series of chance occurrences. Fortuitous encounters, unexpected events, accidents. I never planned my life very much; I never thought of who I would become "when I grew up." But I always liked taking chances. I intuitively took risks in those situations that chance had put me in and was open to experiences that had the power to unsettle me, to open up other possibilities. I also learned to accept events that seemed bad treating them as possibilities for change rather than losses. I learned that a prob-

lem is something that sets us in motion, it's life. And so I find that chance is important for me as long as I remain attentive to it, because in that way I can affirm it. For, as Gal Costa vigorously sang, "é preciso estar atento e forte" (you have to be attentive and strong).

There's a beautiful passage in *Hopscotch* that talks about the affirmation of chance in the encounters between the characters Horacio Oliveira and Maga:

> The technique was to make a vague date in some neighbourhood at a certain hour. They liked to challenge the danger of not meeting, of spending the day alone sulking in a café or on a park bench, reading-another-book … they would agree to meet there and they almost always found each other. The meetings were so incredible at times that Oliveira once more brought up the problem of probability and examined the case cautiously from all angles … What for him had been analysis of probabilities, choice, or simply faith in himself as a dowser, for her was simple chance. "And what if you hadn't met me?" he would ask her. "I don't know, but you're here, you see…" (translated by Gregory Rabassa)

Maybe I learned that from Maga: that chance matters as an opening, so that something may happen; whatever led to it doesn't matter much, and the "What if you hadn't" doesn't exist. Like her, I like saying, Yes.

The way I work is chaotic, and it always begins by accident. I write down ideas, phrases, I highlight books; but none of this is very systematic until a concrete idea appears. I go on living, absorbing, observing, feeling, exchanging. At a certain point, the work reveals itself as a result of anxiety, a problem, insomnia, issuing from a certain material or a retained image, a conversation. That's where the daily work of completion really begins. This can be short or long, as it was with the installation *Rayuela* (Hopscotch, 2005), which took me a year.

Cortázar's *Hopscotch* begins with a proposal: "In its own way, this book consists of many books, but two books above all." Cortázar invites the reader to choose one of the two possibilities by reading the book linearly or by leaping between chapters following the alternative order he proposes.

The installation *Hopscotch* presents another possible way of reading the novel: most of the text of the book was digitally suppressed by me except for the sentences in which I found motion verbs and the page and chapter numbers. I wanted to propose a reading that would show the movement in the text, which, for me, constitutes the structure of the book, in keeping with the game of hopscotch. The installation encourages the viewer to move within the exhibition space, reading passages at random. What happens in between these dislocations is imagined and lived by others.

Like you, through my work I want to establish a relationship of complicity with the other, the viewer, the participant. An instance of sharing, an exchange, a dialogue. I believe that our relationships with others are what constitute us, both in art and in life.

In 2006 I invited some friends to play a game of dice with letters. There weren't many rules: simply to spell words using the letters revealed after the thirteen dice had been cast. It was provocative, in showing the way a dialogue is constructed on the basis of what players are given by chance, by the circumstances. The games were always played in pairs, recorded, and shown simultaneously on thirteen monitors in the installation *Between Us*.

The piece takes place in two stages: an intimate one happens when people agree to play the game I'm proposing, and consequently agree to behave, feel, and think about the situation they are experiencing. This also happens with you and your kidnapper in *Stories of Not-Seeing* or with the people who switch homes in *Two-Way Street*. The other level, which is more public, is the installation itself, which makes room for a certain violation of that intimacy when its viewer observes the thought process of the other when constructing each word. The viewer becomes a third player: he or she tries also to spell out words, imagines the possible ones that have not been spelled out. This happens too with the viewer who begins to decode the signs of the homes that appear in your *Two-Way Street*, or the reader who becomes an active participant by establishing the connections between words and images in the *Stories of Not-Seeing.*

I see there is indeed a confluence in our procedures. Perhaps that is our way of experiencing what our projects provoke in others, and also the way in which others modify them, sometimes also provoking changes in us. I remember your last and unexpected kidnapping: it subverts the rule in a way that interests me. In the beginning, you didn't know that that kidnapping was a game, a joke, just like the others. The situation seemed to escape your control.

I find also that we both use procedures involving game situations, the establishment of rules. What is it that interests you about games? What is the role of chance in *your* work and in *your* life in general?

CG Games are at the core of any social relation. Games and lies. When we run into someone we ask, almost immediately, mindlessly, "How are you?" and we hear, almost automatically too, "Fine, thanks!" Both you and the other will instinctively affirm a false state of well-being in order to establish contact (at least in the beginning). We need to lie about our real state in order not to "scare" the other away.

We need rules for social interaction, and the social fabric (which is also constantly changing) also needs rules in order to preserve a certain state, a way of life. But rules, like games, get old; they can't keep up with social transformations. That's why it's necessary to lose control, almost to force a lack of control in order to reinvent rules as well as games.

When I invent a game, I'm interested in other forms of perceiving reality. I'm not interested in games as competition. I like my games to be open, games in which all participants have something to win. Not in the sense of victory, but in the sense of evolution. Generally, participants take part voluntarily and willingly. More than participating, they offer themselves. They are courageous, in the sense that they open up their lives, their homes, their time, because they know they're participating in an experiment propitiating a lack of control which means coming into contact with a world different from their own.

As is the case with most games, reason and chance play key roles in their development. But when the goal is not to win, you don't have to

think too much; on the contrary, this allows for your porousness to emerge and, in turn, for a better absorption of the experience. When partially liberated from reason (in order to enter the space of games), you allow chance to become the helmsman of the situation. Albert Camus has a wonderful phrase on the subject: "Chance is the God of reason." Reason as the intrinsic and qualifying feature of the human race (and generally used incorrectly in order to affirm the superiority of the species) is subjected to another element, much more flexible and mysterious, and thus seductive: chance.

Andarilho (Drifter), my last feature film, deals precisely with something that touches upon this discussion—the relationship between walking and thinking. In contrast to Descartes, my phrase would be, "I walk, therefore I think!" I am a walker, I always prefer walking to any other form of transportation. When I am walking, my thoughts wander aimlessly. I once began to try (in the second part of the walk) to go backward, to try to recall my train of thought and discover the associations that had led me to think what I had thought at the moment of walking forward. It is really a fascinating exercise! I then thought about making a film about drifters, people who simply spend their life walking. If I, a domesticated, big-city walker, already notice my thoughts wandering in such a delirious way when I walk, imagine what happens to those who spend their lives walking! And, when I made the film and had contact with its characters, I felt the force of chance in their lives. One of the walkers, when arriving at the crossing of two highways (one leading to the north of the country and the other south), told me that he didn't think much about the direction he should take, but that he simply followed intuition and chance. The same thing happens in our own heads when we are walking. How many ethereal roads, how many crossroads must a thought come upon until it takes shape? The gray matter of the brain, the gray matter of asphalt, surfaces, and labyrinths that both feet and thoughts go through. Are you interested in going somewhere or is dislocation what really matters?

MD I thought of a funny story that has a lot to do with our conversation about games. In 2003,

Cinthia Marcelle and I created a pieced called *O Grande Bingo* (The Great Bingo). It was a performance/game that seemingly works like any other bingo. The players each buy a card with seventeen numbers for R$1.00. Each player can buy only one card. The game begins: we call the numbers according to the balls drawn from the cage; at the same time, a close-up of the hand with the ball appears on the screen. When the card is filled, *bingo!*—everyone wins at the same time, because all the cards have the same numbers, except that they are printed in a different order. All players get a prize which is the same amount raised by the card sales divided by the number of winners, that is R$1.00. *The Great Bingo* was carried out twice and in both occasions we were able to enjoy what was happening when the players realised that they all had the same numbers. They continued to play all the same, even more excited than before, and joyous when the moment of the shared victory arrived. The funny story is as follows: I was speaking with another artist, and he asked me about "that bingo game you did in which *no one wins*." I was shocked, because for me and Cinthia, and I believe that for the participants too, it was a game in which *everyone won*. In his statement, the force of a capitalist paradigm was obvious: it is as if *winning* always meant to have an advantage over others, never being in a position of equality.

Games create a situation that reveals one to oneself and to the other, as well as the relationship that is established and the context itself in which we are immersed. That's how I saw the game of dice in *Between Us*, the silent crossword puzzle in *Movimento das Ilhas* (Movement of the Islands); and also how Cinthia and I saw the game of bingo.

About dislocation: in my life I've always been guided by intuition, like the drifter in your film. Intuition is a way of being attentive to what happens, to bet on chance and the unknown. What is interesting about these detours, changes in course, departures and returns is that, after a while, they always reveal themselves to have been motivated by reasons other than those I had thought guided my choice. Or better yet, other than those that I had come up with to rationally justify a certain choice at a certain time.

For me, dislocation didn't have an ultimate goal, its motive was change itself. And that's why I don't think about *where to go*, I think about *where I am*.

I remember choosing to write my first essay for a philosophy class on the figure of the wanderer. It began with a quotation by Nietzsche: "He who has come only in part to a freedom of reason cannot feel on earth otherwise than as a wanderer—though not as a traveller towards a final goal, for this does not exist. But he does want to observe, and keep his eyes open for everything that actually occurs in the world; therefore he must not attach his heart too firmly to any individual thing; there must be something wandering within him, which takes its joy in change and transitoriness."

The video *Hic et nunc* (Here and Now) that I produced in 2002 deals a bit with being open to the present and to change as part of my work process. Rosalind Krauss defines the verbs in Richard Serra's *Verb List* of 1967–68 as machines that are able to build his work. *Hic et nunc* was my set of machines. I began making my own list of verbs: which included the verbs *to forget*, *to dialogue*, *to err*, *to play*, *to move*, and, again, *to forget*. Each of the seventy-two verbs on the list was written by my right hand on a whiteboard and then erased by my left hand: I write *to forget*, then I erase, I write *to experiment*, then I erase, I write *to multiply*, then I erase, I write *to want*, then I erase, and so on, until I arrive once more at *to forget*. The video that records this process is played in a loop and projected onto the same whiteboard.

Today, five years later, I am still finding that my work process is guided by that fleeting quality, by that close attention to the present, without any pre-established forms or rules. It is made new every day. And the verbs change from day to day. What is the process like for you?

CG The other day I met an ex-classmate at the airport. It had been thirty years since we had last seen each other. To my surprise, she told me she remembered me as a good student, always walking around with a battered book bag. I told her that I was never a good student and that appearances can be deceiving. I was always too lazy to complete assignments and fulfil duties, especially the ones I had no interest in. *Ócio*, the Portuguese word for *idleness* (from the Greek *scholé*), is derived from the word *school*. The day I found that out I felt a kind of confirmation of what I intuitively had been practicing from the time I was a schoolboy. One of the foundations of my work process is idleness. I could thus say that one of the "machines" that can build my work is not a verb but a noun designating a state of being. At least in the beginning. Before acting one has to let oneself be overtaken by the desire to act, one has to let oneself be won over by that willingness. And I feel "willingness" as a kind of cloud or atmospheric coating that slowly begins to envelop my being; it generally appears when I'm comfortable, that is, when I'm available and open to the arrival of this willingness.

The "school" of idleness, contrary to what it might seem, especially in the world we live in, doesn't easily grant diplomas. It's what society rejects the most, because if the word "school" has acquired a positive meaning in modern society, the word "idleness" goes completely against what it values. The "idler" has become synonymous with "bum," which negates the etymological nobility of the Greek word. Being idle means being open to knowledge. There's a difference between "not doing anything" and "doing nothing." When I'm "doing nothing," I'm dealing with an absolute, Nothingness (a divine word!). When "I'm not doing anything," I'm doing whatever, I'm a useful being to a society that privileges, precisely, "whatever."

This suggests the old idea of the uselessness of art. To make a piece of bread and to paint a piece of bread. Between the verbs, *to make* and *to paint*, there's a noun, *bread*, which needs to be eaten. Which of the two breads is more nutritious—the one eaten by the mouth or the one eaten by the eyes? When I'm eating bread, I'm clearly delaying my death, but when I see the painting of bread, wouldn't I be learning how to die better? To do Nothing, wouldn't that be learning how to die?

After this entire discussion, I've arrived at a phrase that could be written on my tombstone: "I spent my Life producing Nothing in order to learn how to Die." I know that it's worth nothing but at least it's something…

There's yet another verb I would add to this "verbal machinery of the construction of a work": to die.

Because I think about death as transformation. One of my first films is entitled *Between – Inventário de pequenas mortes* (Inventory of Small Deaths). What follows is a brief text that I wrote on this work and which reveals my conception of death:

> We are used to talking about one death only. As if the limit of one life was bounded on one side by birth and on the other by death. In case we begin to widen the concept of death, we will vertiginously deduce that it is present in everything, in each micro-particle of one life and that the boundaries are expandable. The limits are precisely this place where death and life mix together in the tenuous expressiveness of a change. Millions of cells die in our bodies every second, we fill and empty our lungs with air every second. Between is the place and the moment of the passage. It separates what is inside from what is outside, what passes from what remains, what goes through from what is left.

Another verb in your verbal inventory that is crucial to my work process is "to err." I could almost affirm that I only get things right when I make mistakes! Because nothing shakes up certainties more efficiently than mistakes. And certainties are the things that most harden the human soul. Certainties trap our souls, they leave us without the desire to try different things, without access to newness. To make mistakes is to be free, to open the gamut of possibilities. When we give up certainties we liberate our being so that it may reinvent itself.

Finally behind these three powerful forces that permeate my work process—idleness, death, and mistakes (interestingly, three things considered deplorable in any factory or modern school, which proves that art has nothing in common with capitalist production, profitability, or whatever *is* learned in school)—there is a fourth latent and omnipresent force: movement! Idleness, death, and mistakes generate movement.

Idleness as the ability to absorb willpower and desire. Death as transformation. Mistakes as freedom of expression and the search for the new. Movement is life itself, a constant fluidity, a river that, while appearing the same, is nevertheless always different.

MD Your letter arrived on a day I suffered a small death. I was cutting some paper and suddenly the paper knife fell from the table and buried itself in my leg. It was not a big accident—the cut was only a couple of inches and not very deep, really—but from the time I was a child, the sight of my own blood makes me faint. The prospect of fainting is always worse than the accident itself because fainting means completely losing control, assuming fragility in a very concrete way, experiencing a small death. I was at home by myself, and I tried to regain control by putting salt in my mouth. I thought I was no longer dizzy when all of a sudden I found myself on the floor. When I managed to get up, I called my boyfriend asking for help. Asking for help is not something I would have done some time ago, because I used to confuse being strong with being self-sufficient. He came over, cleaned my wound, cooked lunch for me, took care of me. That's something my work has taught me: to acknowledge that I need someone else.

I agree with you regarding the verb *to die*, in the sense that I only create something based on an event that demands or requires me to change. Often, that appears in my work as a call for help, for company. Because such experiences of death are very lonely. And to transform them into work sometimes involves wanting to share that solitude, saying, "Come, let's do this together, give me a hand." I find that in my work I try to be optimistic, I try to learn to live better. And to live better also means to die better.

That word that is also important in my process now appeared: *solitude*. Often, in my work, I want to invoke it; at other times, I want to get away from it. I find that art is a way of balancing those two states—being together and being alone.

To speak about idleness also means to speak about time, how to deal with it. In 2004 I produced a piece called *A meia-noite é também o meio-dia* (Midnight Is Also Midday). It was an apparently ordinary clock that mechanically displayed a modified, slower notation of time. In this analogue clock, to make a full turn takes

the hands twenty-four hours instead of the usual twelve hours. The clock, then, always shows a different time, it's sometimes slow and sometimes fast and coincides with Brazil's official time only at noon. The piece strongly affirms my will to oppose the time we now live in—a time in which speed and productivity are our greatest goals—and all the anxiety it generates. To affirm a slower time allows for idleness, contemplation, nothingness.

I was struck by the fact that your last phrase was "A river that, while appearing the same, is nevertheless always different." This concept, derived from Heraclitus, also appears in my first artwork, *O Livro de Areia* (The Book of Sand), from 1998.

In Borges' short story "The Book of Sand," he encounters an infinite book whose pages never repeat themselves. I built an object based on that text and the fragment by Heraclitus in which he argues that no man can step twice in the same river. It is a book with pages made from mirrors, the image of infinity for Borges and of becoming for Heraclitus. The reader of this book, or any other book, in fact, will never find the same meaning in its pages, even if they remain the same. It is a eulogy to movement, to life.

This interview was originally commissioned by, edited, and published in *Bomb Magazine*, no. 102 (Winter 2008), pp. 32–41. © Bomb Magazine, New Art Publications, and its Contributors. All rights reserved. The BOMB Digital Archive can be viewed at www.bombsite.com

Translated from Portuguese by Odile Cisneros

ON 0001032201

THE STORYTELL
ERS. A SPECTACUL
ES IN INTERNA

WENDT SELENE

SKIRA